Canon

HOW TO TAKE GREAT PHOTOS WITH THE CANON D-SLR SYSTEM

Canon

HOW TO TAKE GREAT PHOTOS WITH THE CANON D-SLR SYSTEM

Rob Sheppard

LARK
BOOKS

A Division of Sterling Publishing Co., Inc.
New York / London

Editor: Rebecca Shipkosky
Book Design and Layout: Ginger Graziano
Cover Design: Thom Gaines – Electron Graphics

Library of Congress Cataloging-in-Publication Data
Sheppard, Rob.
 How to take great photos with the Canon D/SLR system / Rob Sheppard. – 1st ed.
 p. cm.
 Includes index.
 ISBN 978-1-60059-461-8 (pbk. : alk. paper)
 1. Canon digital cameras–Handbooks, manuals, etc. 2. Single-lens reflex cameras–Hand-
books, manuals, etc. 3. Photography–Digital techniques–Handbooks, manuals, etc. I. Title.
 TR263.C3S5234 2009
 771.3'2–dc22

 2009022059

10 9 8 7 6 5 4 3 2 1

First Edition

Published by Lark Books, A Division of
Sterling Publishing Co., Inc.
387 Park Avenue South, New York, N.Y. 10016

Magic Lantern Guides® is a registered trademark of Sterling Publishing Co., Inc.

Distributed in Canada by Sterling Publishing,
c/o Canadian Manda Group, 165 Dufferin Street
Toronto, Ontario, Canada M6K 3H6

Distributed in the United Kingdom by GMC Distribution Services,
Castle Place, 166 High Street, Lewes, East Sussex, England BN7 1XU

Distributed in Australia by Capricorn Link (Australia) Pty Ltd.,
P.O. Box 704, Windsor, NSW 2756 Australia

If you have questions or comments about this book, please contact:
Lark Books
67 Broadway, Asheville, NC 28801
(828) 253-0467

Manufactured in Canada

ISBN 13: 978-1-60059-461-8

For information about custom editions, special sales, premium and corporate purchases, please
contact Sterling Special Sales Department at 800-805-5489 or specialsales@sterlingpub.com.

Canon

HOW TO TAKE GREAT PHOTOS WITH THE CANON D-SLR SYSTEM

TABLE OF CONTENTS

Introduction

HOW TO TAKE GREAT PHOTOS WITH THE CANON D-SLR SYSTEM

BY ROB SHEPPARD

The world is filled with wonderful things to photograph, and Canon offers great systems of cameras and lenses to enable you to do just that. There are many excellent books available about photography, but few can be used as a quick guide to working in the field with your camera. This book is designed to help you with that.

You will find a whole range of techniques and tips that I have found have helped me take better pictures, ideas and possibilities that I believe can help you, too. I can guarantee that if you put the ideas in here to use that you will gain more control over your photography. Sometimes I hear that photographers wonder what secrets the pros know that enable them to take the pictures they do. This book includes many of those secrets.

The book is based on using Canon cameras and lenses. Of course, good photography does not require a specific brand of camera, no matter how good that brand is. We all have to pick a camera system to work with, though, and this book offers ideas on how to refine your photography using Canon gear.

This is not a guide to the specific operation of any given Canon camera, however. Books like the *Magic Lantern Guide®* Series on specific Canon models do that. To do something like that in this book would make it more of a thick compendium of manuals rather than a guide to actual field work as a photographer. In addition, while Canon cameras have many similar features, they do not all work exactly the same with controls in the same places. You will

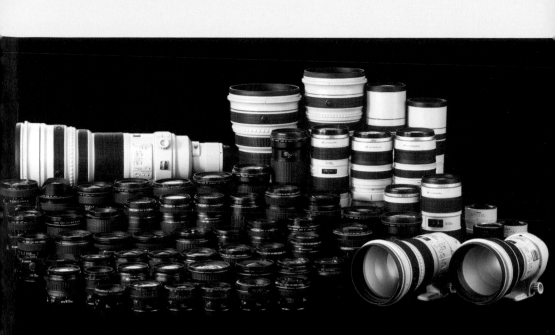

sometimes need to refer to your specific camera model manual or a Magic Lantern Guide to check on a certain control or feature.

I hope this book will encourage you to explore the possibilities of your camera in many situations. You will find a lot of information on how to work with a camera, how to set controls optimally, how to use focal lengths and so on. The photographs that go with each technique or tip are chosen to either represent a Canon camera in use or to show how the technique is applied to a real world subject or scene. My hope is that they will also give you ideas on how you might apply these ideas to your own photography.

You will also find an entire chapter in this book devoted to ideas about photographing types of subjects, this as well as shooting advice peppered throughout, is not meant as a complete guide, but it is a place where you can quickly find ideas and possibilities that work. The photographs are real images I have taken in my work as I have traveled across the country and the world. My goal is to give you ideas with sample images that you can use right now.

One thing that is always hard to do when putting together a book like this is to show photographs of every sort of subject that readers might be interested in. The photos chosen were selected to show off how the technique or approach works, not for specific subject matter. These techniques go far beyond the subjects seen in a specific photo. Read the technique or tip, look at the photo, then think about how you can use that idea in your photography. Go beyond the literal in the subject matter to find the truths of good photography that you can apply to your own work.

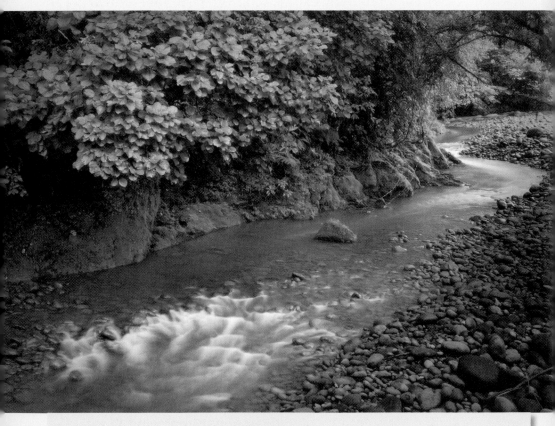

Don't be afraid to experiment and try new things. Shoot a scene like this with as many variations on shutter speed, aperture, Picture Style, etc., as time allows. That is the way you will find your own style of shooting.

Above all, have fun! I feel a bit sad when I see photographers get too intense about taking "perfect photos." When I do classes, I sometimes get students who are determined to prove that they can do great images for any assignment. Why? As we learn new techniques, shouldn't we be trying things we don't know how to do? And if that is true, wouldn't we naturally be making mistakes as we learn?

One of the great things about digital photography is that there is no cost to taking pictures once you own the camera, lens, and memory card. You can freely experiment with new ideas, even play with your camera to discover new possibilities, and there is no cost to doing that. If that means trying something and it doesn't work at first, so what? At least you have learned what doesn't work! And that instant image on the LCD lets you try things with immediate feedback so you can refine your technique as you go.

If you are not sure about how a technique works, if you don't find quite enough information here to help you understand it perfectly, just try it. Go out, turn your camera on, and take some pictures using the technique the best you can. Then look at the results and try something different. I guarantee you will learn a lot that way.

I have a variety of information about digital photography on my website, www.robsheppardphoto.com, and at my blog, www.photodigitary.com. This includes information not only about photography, but also about processing digital files. Canon cameras do a great job of image capture, but it is still an interpretation, regardless of whether it is RAW or JPEG. That interpretation is based on sensor limitations as well as engineering design decisions that may or may not interpret your subject and scene as you saw it. You may find some helpful ideas about improving those images on my websites.

Now, get started on an adventure in better photography with your Canon camera!

Camera Basics

BEFORE YOU SHOOT

How you set up your camera can make a big difference in how easy it is to use in the field. Through the classes and workshops I've conducted, I've seen how well the following set-up choices work for photographers using Canon cameras. However, every photographer is different, so you should try these to see if they work best for your situation. You might try one of these ideas and wonder why on earth I suggested

it. That's okay. It doesn't mean that either one of us is wrong, simply that we work differently. A properly set up camera must work for the individual.

POWER

Batteries: Though you don't "set up" batteries, making sure you have charged batteries is vitally important to the preparation and operation of your camera. There are few things more disappointing than having your battery die while photographing something exciting.

I recommend the following to ensure that you're never without juice for your camera:

Always carry a fully charged backup battery in your camera bag. This will ensure that you'll have enough power!

1. Own a minimum of three batteries.

2. Have one charged battery in your camera.

3. Have one charged battery in your camera bag.

4. Have one battery being charged while the others are being used.

It is rare that you will use more than two batteries in a day of shooting with recent Canon cameras, so having three batteries allows you to make sure two are always charged while the third is charging. When you finish a day of shooting, take the now-charged third battery and put it into your camera. The most discharged battery then goes onto the charger. By rotating in this way, you will always have one fully charged battery and one that is at least mostly charged, with a third one charging, and you won't need to skimp on the features you want to use because you'll always have that backup.

Auto power off: It is extremely frustrating when something great is happening in front of the camera and you find the camera is asleep when you try record the scene. This often happens because the Auto Power Off is set too low. The default setting is generally about a minute, which is not long enough for most photography. We can all thank the Canon engineers for trying to help us save our batteries, but this setting simply doesn't work for most photographers.

Find [Auto Power Off] and change it in the Setup menu. When selecting one of the options, you might have to think a bit about the type of photography that you do. I would start with four minutes and see how it works. If that seems too short, change it to a higher number as needed.

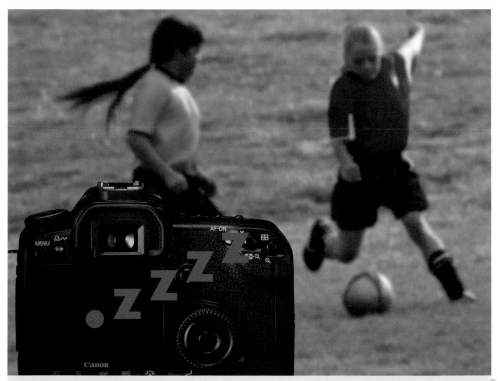

The Auto Power Off setting on Canon cameras is designed to save battery power, but you may find yourself at times powering the camera back up for a shot rather than capturing it. I recommend setting the Auto Power Off for longer than the default, or turning it off completely.

CHOOSE A FORMAT

All Canon digital single-lens reflex cameras (D-SLRs) offer both JPEG and RAW image formats (how the photo is saved on your memory card). You may also find JPEG and RAW on some advanced non-SLR Canon digital cameras, but only JPEG is available on the less advanced Canon digital cameras.

Both JPEG and RAW are capable of excellent results. JPEG is a compression format, and Canon cameras usually offer several levels of compression (or quality). JPEG "smartly" removes redundant data from the digital image to make a photo file that is significantly smaller than full sensor resolution. The image is then reconstructed when you open up the file in the computer.

Choosing the file type and size for your images is an important first step when setting up your camera.

Choose your format settings in the [Quality] option of the Shooting menu in your camera. In general, it is best to use the highest resolution and the least amount of compression for JPEG. You get the best possible images from JPEG by selecting the high-quality settings, while lower resolution settings really waste the capacity of your sensor. So, if you want to record JPEGs, select the icons that indicate full resolution and the lowest compression rate—L◢ .

JPEG is a great choice for shooting lots of pictures that you want to access quickly. It allows you to shoot more photos consecutively before the camera pauses to store images to the card. And, since JPEGs are smaller than RAW files, the memory card can hold more images. JPEG also is such a widely used

compression format that no further processing is required once the file is recorded to your memory card; this is not the case with RAW. In most cases, RAW files must be converted to a different file format before they can be viewed, printed, or stored.

JPEG, as compared to RAW, can be a great format for shooting sports and other action-based subjects. It allows you to shoot more photos continuously before the camera has to stop to catch up.

RAW is the perfect format for allowing you to get the most from an individual photo. It is a large file that holds far more information about your photograph than a JPEG, resulting in the ability to do more processing when the file is downloaded into the computer. This gives you much more flexibility for working on an image,

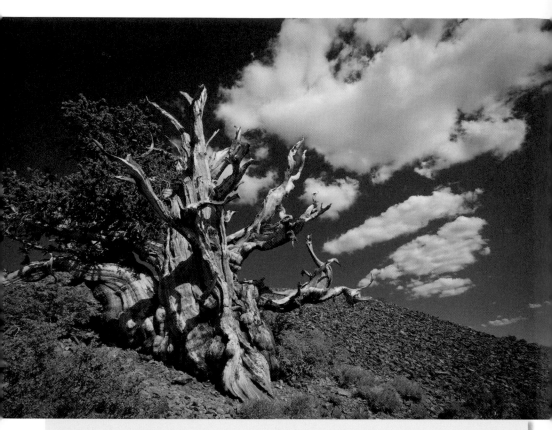

RAW is a good image file choice for high contrast landscape photos, especially those with a lot of clouds and sky. RAW files allow you to capture more detail and dynamic range in the shadows and highlights than JPEG .

especially for digging out detail in the brightest and darkest areas of the photograph. RAW files do not take on most in-camera processing settings made at the time of shooting. Depending on the processing software you use in your computer, they will usually carry instructions from the camera based on the settings you made, but those settings are by no means permanent for RAW files. You can easily change any of them in post processing.

Many Canon D-SLRs have more than one setting for RAW. In addition to the regular RAW setting, there is often another type, called sRAW. The latter is a specialized format that makes a smaller RAW file, still giving you the freedom to make a lot of changes in

post-processing, but in a smaller file that takes up less memory on your card. I recommend the RAW setting because it uses the sensor's full potential, giving you the best possible image quality from the camera.

RAW plus JPEG is also an available option on most Canon D-SLRs. This records a RAW file and simultaneously makes a JPEG file that can quickly be printed at home or at a photo lab. Shooting RAW plus JPEG, however, does mean you need a large memory card.

The following chart shows approximately how many images will fit on a 2GB memory card. The vertical axis represents maximum resolutions available on various Canon cameras, while the information on the horizontal axis is the file types those cameras offer. Where N/A is in place of a quantity, no data is available because the cameras of that resolution do not offer the particular file type. Card capacity can vary slightly from brand to brand, but this chart is based on a 1.9GB actual capacity, with the remaining space being used for information that must be on the card for it to operate properly. Most cards on the market do have slightly less capacity than advertised for this reason.

File Type	RAW	RAW+L/Fine	sRAW1	sRAW2	L/Fine	L/Normal	M/Fine	M/Normal
21.1	74	60	128	176	311	633	528	1000
15.1	94	75	151	207	380	760	633	1188
12.2	124	97	N/A	N/A	442	864	760	1462
10.1	194	140	N/A	N/A	500	950	826	1583
8.2	218	154	N/A	N/A	528	1056	864	1727
6.3	317	N/A	N/A	N/A	760	1462	1357	2714

Camera Res (mp)

MEMORY CARDS

Obviously, you want to be sure that you have enough memory for any photography that you have planned. Memory cards are now relatively inexpensive for their capacity, so it is worth having enough memory for any photo possibilities. There is a large variety of memory cards available—different brands, capacities, read/write speeds, etc. Although

Canon D-SLRs use either Compact-Flash (CF) or Secure Digital (SD) and high capacity Secure Digital (SDHC) cards. Check your camera's manual to see which type you need

just about any quality memory card will work with your Canon camera, you should always test a new card before going out to take pictures.

Formatting a card: Formatting the card essentially clears it of all data references except for that small amount of information that is required for the card to work properly—it's basically like when you defragment your computer's hard drive. Sometimes photographers will simply keep using the same card, deleting pictures they don't like, shooting until it's filled up. It is fine to delete pictures that you don't like from a given shoot; however, if you keep deleting images from a card that you use continually without formatting once in a while, you may get a corrupted file structure, which can make it difficult to access your pictures.

To avoid this, regularly download the images from your card to your computer or other storage device, then format your card in the camera. Formatting is done in the Setup menu on Canon cameras. It is a good idea to regularly format your card so that you don't have problems reading it later.

SET THE ISO

A full discussion of ISO can be found on pages 43-46, but to get you started, here are the basics. ISO determines how sensitive the sensor is to light. You always want to set the lowest ISO the situation will allow, because lower ISOs produce better image resolution and color saturation. High ISOs are characterized by a lot of grain in the image, so unless you absolutely need that extra sensitivity or you're going for that grainy look, stay away from the higher numbers. The following are some basic guidelines for selecting the right ISO:

◆ **200 or lower:** outdoors on a sunny day

◆ **400:** indoors in a fairly bright room or with flash

◆ **800:** indoors with some existing light and no flash

◆ **1600 or higher:** very low-light situations, like concerts, restaurants with mood lighting, etc.

CHOOSE A SHOOTING MODE

Most Canon D-SLRs have a dial somewhere on the top of the camera, either to the right or the left of the mirror box. This is the Mode dial (pictured on page 53). Turn this dial to select a mode based on the type of shooting you plan to do. The Av, Tv, P, and M modes leave more of the camera controls to you, while the remainder of the modes available on the dial vary from camera to camera. These modes often include automatic settings for specific situations like Sports, Landscape, Portrait, and others.

Exposure modes: The exposure modes are Aperture-priority (Av), Shutter priority (Tv), Program (P), and Manual (M). It is a good idea to find one that suits you and use it consistently so that it becomes second nature. Most serious photographers will choose Aperture-priority, Shutter-priority, or Manual exposure. This is not because the other modes give inferior quality, but rather because these modes give the photographer the most flexibility.

Av, or Aperture-priority, means you choose the f/stop and the camera selects the shutter speed. This is very good for controlling depth of field. Tv, or Shutter-priority, means you choose the shutter speed and the camera selects the f/stop. This option works well when you need to stop action. In M, or Manual exposure, you choose both settings, which is great for when the exposure is too tricky for the automatic system to handle. The P, or Program, mode sets both the aperture and shutter speed for you, thereby limiting your control over the image. Program mode does, however, allow considerably more flexibility than Full Auto, in that you can toggle between Av and Tv—i.e., if you change the aperture the camera will set shutter speed accordingly, and vice versa.

Auto modes: There are additional program modes on all Canon cameras—how many and which ones will vary from model to model. The more professional-oriented cameras may only offer one Auto mode in addition to the exposure modes, while the "pro-sumer" (high-end consumer) cameras will offer a range of auto-matic modes for specific types of photography, such as action or close-ups. These can be helpful in aiding your exposure decisions for certain subjects, but they can also limit your ability to deal with unique conditions, as you will not be able to set many things on the camera yourself, including ISO sensitivity.

Custom modes: Some Canon D-SLRs also feature custom, or camera user, modes on the Mode dial. These modes simply allow you to set the shooting parameters that you prefer and assign them to a mode on the dial. Then, to recall your personal settings, all you have to do is turn the dial to that position, rather than make all of the settings each time you pick up the camera.

NOTE: See pages 53-56 for a complete discussion of exposure/ shooting modes.

SELECT A METERING MODE

Canon cameras offer several metering modes, although there are some differences among the various models. A complete discussion of metering modes can be found on pages 50-53, but to get started, you will need to select a metering mode. Most photographers, beginner to pro, will find the Evaluative metering system to be a standard setting they can use all the time. This is a multi-point metering system—the camera measures the light from many distinct points across the entire image area and then intelligently computes an exposure. It does not average those readings, but uses the camera's computing power to create an exposure based on comparing and evaluating all of those points, along with focus distance information. This is why Evaluative metering is a complete system, not simply a fancy name for an exposure meter.

The Evaluative metering mode is perfect for images with multiple subjects needing an overall exposure reading; Evaluative metering measures light across the entire scene.

FOCUS SETTINGS

Canon cameras use multiple focus points to find focus automatically, as seen in the image above. These are not actually points, but an array of sensors that detect sharpness in different ways, as shown in the illustration on page 26.

The camera can select the AF point automatically, or you can manually select a desired point (the controls vary by camera model).

Manual AF point selection is useful when you have a specific composition in mind and the camera won't focus consistently where you want it to.

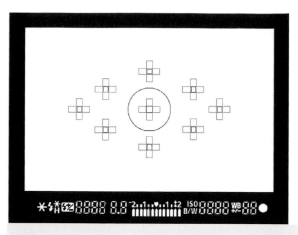

Canon cameras are built with several different focusing methods and most cameras offer several autofocus (AF) modes, plus manual focus. The autofocus modes are One-Shot AF; AI Servo

Canon has engineered specific AF sensors spaced across the viewing area that can quickly find and focus on key parts of your subject. In addition, certain sensors, such as the center sensor, are cross-type, designed to achieve the highest accuracy.

AF; and AI Focus AF. Access these AF modes in D-SLRs by pressing the AF button on top of the camera, then scroll to select the mode using the Main dial behind the shutter button. Each mode is used for different purposes.

One-Shot AF is the most practical mode for the majority of situations, although AI Servo, because it constantly focuses rather than locking focus on a fixed subject, is better for action shots—like wildlife photography or a sporting event. AI Focus allows the camera to switch automatically between One-Shot and AI Servo, based on whether or not the camera detects movement; but I don't recommend this mode because it can be easily confused by motion that is not intended to be captured, like a tree blowing in the breeze right next to your stationary subject, for example. (See page 67-71 for more information on the autofocus modes.)

Some Canon D-SLRs have an AF-ON button. This button allows you to use your thumb to start the autofocus when the action gets intense. This ability to activate autofocus with a separate button prevents the problem of taking an unintentional

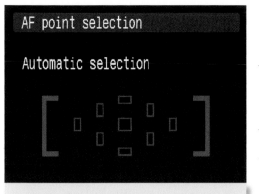

AF point selection

Automatic selection

You can allow the camera to choose the best AF point for focusing as it reads the scene, or you can choose a specific point for special focusing needs.

The type of AF set on your camera will appear at the right side of the top LCD panel on your camera if your camera has an LCD panel. If not, you can find this information in the Quick Control display on the LCD screen.

picture while pressing the shutter halfway to start autofocus, because AF-ON can also be used to lock focus. It also avoids exposure problems that could result from locking AF and AE at the same time, because you may want to, for example, focus on your subject, follow it into different lighting, and then expose for that new light.

DRIVE SETTINGS

Canon D-SLRs have multiple drive modes (sometimes called shooting modes), depending on the model. However, all cameras offer Single shooting (one image at a time) and Continuous shooting (multiple images are captured as the shutter is held down). Some cameras offer High-speed Continuous shooting and Low-speed Continuous shooting modes. For general shooting, you will usually choose the Single-shot drive mode; for action, choose a continuous mode.

Another option on most cameras is the Self-timer and it can usually be set for either two or ten seconds (some models only offer the ten-second delay). It can be used in any situation where you need a delay between the time you press the shutter button and when the camera actually fires. The ten-second delay is most commonly used when the photographer wants to be in the picture.

Ten seconds is enough time for you to get in front of the camera and situate yourself in the frame once you've composed the image and pressed the shutter button. The two-second timer is most useful when using slow shutter speeds on a tripod, because the delay eliminates the camera movement that normally occurs when you press the shutter button, but it isn't such a long delay as to be impractical.

Drive modes are typically selected by pressing a drive button AF•DRIVE, then rotating the back dial or using control buttons to arrive at the desired option.

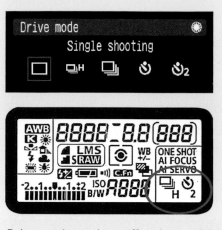

Drive mode settings affect how quickly your camera will take pictures consecutively as well as Self timer settings. These settings appear either in the LCD panel or in the Quick Control display, depending on the camera model.

IN-CAMERA PROCESSING

White balance: White balance (WB) is a setting on a digital camera that changes how the camera responds to the color of light. It is designed to make neutral colors (such as white) appear neutral in a particular light, without a color cast from that light. There is a chapter dedicated to white balance later in this book that goes into more detail (see pages 98-115). This quick overview gives the basics you need include white balance when you set up your camera for shooting.

Like ISO settings, WB settings on D-SLRs are changed by pressing a dedicated white balance button and using a control dial (or back buttons), or are found in the Function menu on other types of cameras. All advanced Canon digital cameras let you choose among several white balance settings:

◆ **Auto white balance:** The technology of Auto white balance (AWB—the default setting of digital cameras) has made huge advances and can often give you great results, especially in tricky and changing light conditions. However, AWB can give inconsistent color when you are taking multiple shots while changing the angle, composition and focal length—even when the light remains the same.

◆ **Preset:** Preset white balance settings allow you to match the white balance setting to the conditions in which you are shooting, e.g., Daylight setting to a sunlit scene, Shade setting to a shady subject, Tungsten setting to an indoor situation, and so forth. This can do a great job of rendering colors accurately.

◆ **Custom white balance:** Custom, or manual, white balance tells the camera to make a specific tone neutral. Put a neutral target in front of your camera and in the same light as your subject (this can be a white paper, a gray card, white fabric, or even specially made white balance cards) and take a picture of that object. Then go to the Shooting menu, to [Custom WB], and follow the directions there. Make sure that

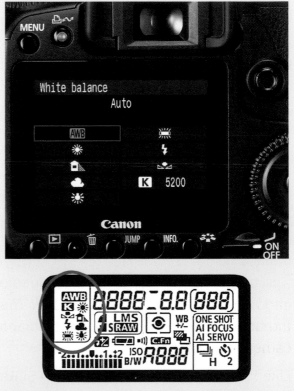

White balance is critical in digital photography. Auto WB is the default setting, but it can give inconsistent results compared to choosing specific white balance settings.

your exposure makes the white or gray object record as neutral gray in tone, not white.

◆ **Kelvin:** Kelvin settings allow you to pick a specific color temperature in the Kelvin (K) scale to affect how your camera records the color of light.

Choosing color space: A color space defines the range of colors that your camera will interpret in a photo and how that range will be handled. It is a standard that will be recognized by your computer and the software you use to process the image. Adobe RGB (1998) and sRGB are the two photographic color spaces available as choices with Canon cameras at the time this book is being written. Note that these choices only affect JPEG files, as you choose your working color space with RAW files when you process them in the computer.

Adobe RGB gives a greater range of color compared to sRGB, which means it offers more possibilities for adjustment. Think of it this way: Adobe RGB is like a bigger box of crayons than sRGB. However, both color spaces work well (kids do just fine with small boxes of crayons; they just have a few more limitations when coloring a picture).

If you are going to work on your photos in the computer, you will usually find that Adobe RGB gives you more flexibility and better options for color adjustment. If you are going to make a print straight from the camera's image files, you may find that sRGB gives you better results. You might consider this the way film photographers approached different film choices—you can work within either space and decide to optimize your prints for that particular one, or you can select the space that best meets your color print needs (but test this, don't go by what someone says you should do).

Picture styles: Many Canon D-SLRs include a feature called Picture Styles. These are settings that apply in-camera processing to an image before it is saved to the memory card as a JPEG (Picture Styles are tagged to a RAW file's metadata, too, but can only be read by Canon image processing software). This can be especially helpful if you are printing image files directly from the camera without using a computer, or when you need to quickly supply a particular type of image to a client. Access these settings by pressing the Picture Styles button on the back of the camera. (In older Canon cameras, the same controls are called Parameters.)

Each Picture Style controls the degree of in-camera image processing applied to four aspects of an image: Sharpness, Contrast, Saturation, and Color tone. Sharpness refers to the amount of sharpening that is applied to the image file by the camera. Contrast will increase or decrease the contrast of the scene that is captured. Saturation influences color richness or intensity. Color tone lets you decide how red or how yellow to render skin tones, but affects other colors as well. The Picture Style choices are:

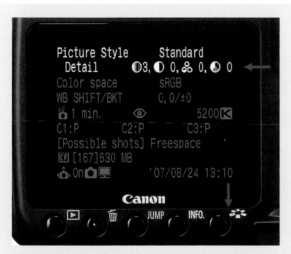

Picture Styles affect the look of JPEG images. When available on a Canon camera, they allow you to change how a JPEG image file is processed inside your camera. Picture Styles are usually set by pressing the Picture Styles button to the bottom right of the back LCD.

◆ **Standard:** This makes the image look sharp and crisp, and skin tones are warm. In-camera sharpening is moderate to high.

This is a good setting to use when you want to make inkjet prints and intend to do little or no post processing.

Picture Styles choices are totally discretionary—there is no best setting. Different photographers will prefer different settings for the same subjects. Experiment and choose settings that work for your pictures.

◆ **Portrait:** This is biased toward making skin tones look attractive—they'll appear even warmer than with Standard. The image is not as crisp, though still sharp. In-camera sharpening is lower than in Standard.

◆ **Landscape:** This style is biased toward sharp and crisp landscape photos, as well as vivid blues, greens, and yellows. Sharpening is moderate.

◆ **Neutral:** Choose this style if you want natural colors that are less vivid and intense than normal. Almost no sharpening is applied. If you want to achieve a look that you got used to on an older EOS D-SLR using a newer one, this is the setting that will do it, because Neutral was the color profile of the EOS digital cameras before the days of Picture Styles. This setting is also commonly used for images that will be processed in the computer.

◆ **Faithful:** This style is meant to capture colors accurately as interpreted by Canon engineers (which may or may not seem accurate to everyone). It is very similar to Neutral—the only difference is that it applies a small amount of warmth to the colors, which is great for still-life shots or portraits. The final image is very subdued and no sharpening is applied, so like Neutral, Faithful is often used for images that will be additionally processed in the computer.

◆ **Monochrome:** This changes JPEG color images to black-and-white, but RAW images can still be processed as color photos. In-camera sharpening is low to moderate.

◆ **User Defined 1-3:** This allows you to create custom Picture Styles based on your personal shooting needs. You can adjust any or all of the parameters available in Picture Styles.

LCD SCREEN

The LCD is a very important part of working with a digital camera. This is the place where you can see the images you shoot, as well as the menus necessary for making and changing many of the camera's settings. You will see the images immediately after taking a photo, which is called Review, plus you can view any images on your memory card via the Playback function. In addition, most Canon cameras now have Live View, which allows you to see what your sensor is seeing through the lens in real time.

Reviewing photos on your LCD gives you instant feedback that was never possible with film (even photographers who shot Polaroid tests had to wait for them to develop). This allows you to confirm exposure, check composition, be sure white balance is correct, examine sharpness, and much more. You get a quick look at all of this with Review; and in Playback, you can enlarge the image (with the plus and minus magnifier buttons on the back of the camera), then scroll it around (with either arrow buttons or the

Multi-controller on most Canon cameras) to check details, such as focus or highlight exposure.

Canon cameras also allow you several different displays for images (accessed by the Display or Info button), including full-screen with shooting info, full-screen with no overlays, and histogram displays for checking exposure (more on histograms in Chapter 2). The full-screen with shooting info can be very helpful when you are confirming certain aspects of your shooting, but it is distracting when trying to carefully examine an image. I will often change the screen to no overlays when playing back a series of photos to really see what I have, but I keep the full screen with shooting info on most of the time, and go to the histogram as needed.

USING LIVE VIEW

Available on recent Canon D-SLR cameras, Live View essentially makes the camera act like a compact, non-D-SLR camera, so that a live image is displayed on the LCD directly from the sensor. You now have two choices for viewing your scene before photographing it: through the standard viewfinder (which is bright and clear), or through the sensor via the LCD (which is a direct view, though darker and difficult to see in bright light).

Live View offers a number of advantages: You can see what the white balance looks like, you can get an idea of the exposure, you can see 100% of the frame, you can use it to focus very precisely in certain situations, and because the mirror is already in the up position in order to allow the sensor to "see" the frame and produce the Live View image, you can shoot more quietly (since the majority of the noise produced by an SLR camera is due to the mirror moving out of the way of the shutter before the exposure, and back down after it). However, there are also disadvantages: It is slower than using the viewfinder, it is hard to use in bright light, you can only use manual focus directly (AF is possible, but requires an interruption in view because it needs the mirror), it uses battery power faster, and it can create heat and noise issues.

Go to your Setup menus to enable or disable Live View. On some cameras, you can also turn a grid display on or off (this can be really helpful to compose straight pictures when shooting architecture or landscapes with a distinct horizon).

Because the mirror is locked in the up position in Live View mode, it is possible to set the camera so that it makes virtually no sound when it takes a picture. These settings are referred to as

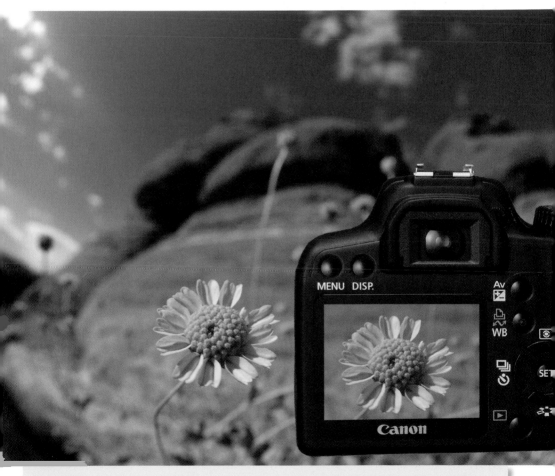

There are distinct advantages when using Live View to compose and capture an image—such as seeing the entire frame of the image—but the disadvantages might make you reconsider whether Live View is the best shooting mode for you. Shooting outside in sunny conditions, for instance, can make it hard to see the LCD monitor.

```
┌─────────────────────────────────────┐
│  Live View function settings         │
│  ┌─────────────────────────────────┐ │
│  │ Live View shoot.   Disable      │ │
│  └─────────────────────────────────┘ │
│  Grid display      Off               │
│  Silent shoot.     Mode 1            │
│  Metering timer    4 sec.            │
│                                      │
│                                      │
│                      MENU ↩          │
└─────────────────────────────────────┘
```

Live View can be changed from a Setup menu. The Grid display can aid composition, especially when working with straight lines, and silent shooting can make your camera shoot with a minimum of noise.

Silent Shooting Modes, and can be accessed via the Setup menu when the camera is in Live View. Canon has incorporated partial electronic shutters (meaning the sensor is used to control the shutter speed) in their cameras to allow you to take a picture with no sound at all as long as you continue to hold the shutter release. These settings, of course, are only available in camera models that offer Live View.

Live View, despite a few disadvantages, is a really valuable feature. It allows you to better see the entire photograph, not simply sight on a subject (which the viewfinder encourages). It also makes it possible to view what the lens is seeing when the camera is above or below eye level, making it much easier to place the camera into a position that would otherwise be difficult if held in front of your eye. I also find it is great for close-up work.

REVIEW TIME

This sets the amount of time that an image displays on the LCD right after you take a picture. I find the default settings on most cameras are too short for review; you should be able to examine a photo for at least a few seconds. If you don't want to review your pictures, then set this to Off, or just turn off the review by pressing the shutter release lightly.

For me, this review allows a quick look at the image to make sure that I have gotten what I expected to get. It immediately tells me

if I am way off on exposure or white balance, or if I am having problems with sharpness. This picture review is one of the great advantages of digital photography because you can be sure you have the shot before you leave your subject and scene.

It is true that a longer review time will deplete your battery's reserves faster, but with today's high capacity batteries and more efficient camera circuitry, this really is not a problem.

Review time is set in the Shooting menu. You will have a choice of Off, several timed options, and Hold. A review time of eight seconds works pretty well for most photographers. You can also choose Hold to leave the LCD review on indefinitely; it only turns off when you activate another camera function, like autofocus or one of the menus, or when you shut the camera off.

How long your LCD displays a photo after the shot is called Review time. The default is usually too short to be of much help when viewing an image you just made; adjust the settings to give yourself a chance to truly review the shot.

AUTO ROTATION

The default setting of most digital cameras automatically rotates vertical images in the LCD when you play them back, so that you see them in a portrait format, as opposed to the horizontal orientation of the LCD itself. This is a bit of a problem because a vertical image in your horizontal LCD is not utilizing the "real estate" of your screen very well—only a fraction of that big, beautiful LCD screen (that is part of the price of your camera) is being used. So, I find it is best to view vertical pictures horizontally in the LCD, so that they're bigger. Most of the time when you are shooting

Many cameras come with Auto rotate set as the default, and many photographers don't realize they can change this setting. Auto rotate displays a vertical image correctly in the LCD, however it must make the image smaller to fit the dimensions of the screen, using the LCD inefficiently.

vertically, you will want to see the picture in the same orientation as your camera anyway.

You can find the settings for Auto rotate in the Setup menu on your camera. Canon now gives you three Auto rotate choices: rotate in both camera and computer, rotate in computer only, and off. The second choice is the best one in my opinion, as it allows your computer to recognize a vertical picture and rotate it for you, but it does not rotate the pictures in the camera's LCD.

CHECKLIST FOR SHOOTING PREPARATION

Some of the things examined in this section are one-time choices—not settings you should be changing every time you go out shooting. However, there are a number of things that you may change regularly, so it is a good idea to check them every time you get ready for a shoot. The most important include:

◆ Confirm file format setting

◆ Format your memory card

◆ Confirm ISO setting

◆ Check white balance setting

◆ Choose an AF setting

◆ Check battery status

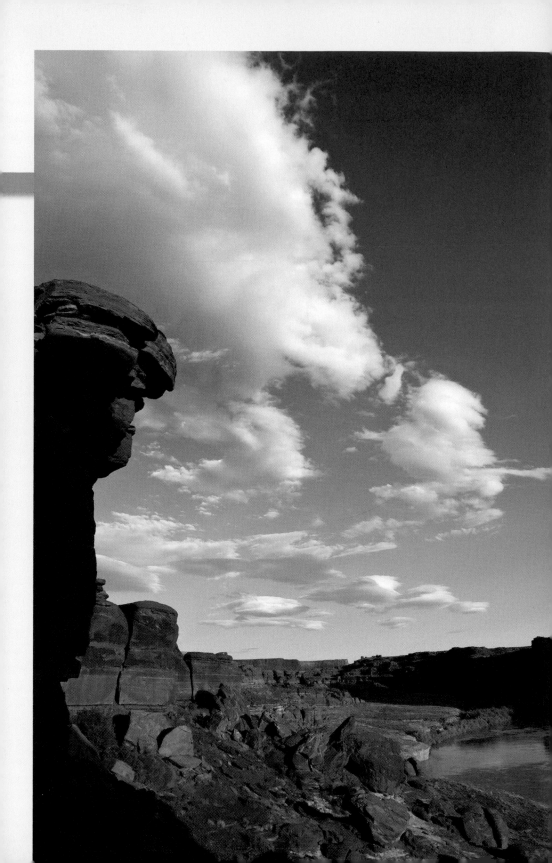

Exposure and Metering

Nowadays, Canon metering systems do a great job of providing good exposures. Years ago, exposure was a challenge for photographers. They had to use hand-held meters, and then they would have to translate the exposure from meter to camera, hoping they did it right.

In their current cameras, Canon offers a choice of metering options, including the sophisticated Evaluative metering. This is a special metering sensor that examines many parts of the image area (how many depends on the camera model), and then the mini-computer built into the camera compares the readings with each other, the focus distance, and a database in order to calculate a reasonable exposure for the scene. In many cases, that exposure is perfect.

But a poor exposure can cause you problems. In digital photography, underexposure can result in more noise, more contrast in the photo, and problems with dark colors. Overexposure can mean that detail is lost from bright areas (and cannot be recovered), plus there will be problems with light colors.

To get the most from your photography, you need to be able to understand exposure and correct the problems associated with shooting conditions and metering errors.

Good exposure means you captured all the colors and tones in a scene, from black to white.

RECOGNIZING GOOD EXPOSURE

Good exposure gives you the right image tonalities so that the brightness of your photo shows off your subject in its best light, literally. Colors are appropriately bright; important colors and tones do not look muddy, nor are they washed out.

Good exposure strikes a balance between highlights and shadows. Sometimes you can get good detail in both highlights (bright areas) and shadows (dark areas) in a photograph if the overall contrast of the scene fits the capabilities of your camera's sensor. However, if the range of brightness in the scene is high, a good exposure avoids washed-out highlights if highlights are critical to the subject; or it avoids dark, solid shadows if detail there is important.

Bright colors should appear bright, dark colors dark—a good exposure will give you both. If bright colors are dark (a sign of underexposure), they'll look muddy and the whole photo will look dim. If dark colors are too bright (overexposed), they will look washed out and the whole photo will appear gray.

Always remember that a good exposure keeps noise to a minimum. Noise appears as grain in the image, very similar to the grain associated with high-speed films—it actually looks like a pattern of sand grains across the image. While it can be a creative option sometimes, most of the time, it is unattractive and distracting. Underexposure always makes noise a problem, no matter what your camera model is. It becomes visible when dark areas are brightened a lot. It was there all the time, but a properly exposed photo keeps dark areas dark, so noise stays hidden.

ISO SETTINGS

ISO is an international standard method for quantifying film's sensitivity to light, and the ISO settings on a digital camera represent an equivalent sensitivity of its sensor. While ISO on a digital sensor is different from that of film, a digital camera's ISO equivalent settings do correspond to film, so that if you set a digital camera to ISO 400, you can expect a response to light that is similar to that of an ISO 400 film.

Low numbers, such as 50 or 100, represent a relatively low sensitivity. Higher numbers, such as 400

Higher ISO settings will give you more flexibility in hand-held shooting, but a low number will usually give better image quality.

A low ISO is usually best for landscape photography because it will give the best detail and color, plus noise will be at a minimum. If you don't need a high ISO setting, you are usually better off not using it.

or above, represent higher sensitivity. ISO numbers are mathematically proportional to the sensitivity to light. As you double or halve the ISO number, you double or halve the sensitivity of the camera or film to light (i.e., 800 speed is twice as sensitive to light as 400 and is half as sensitive as 1600). This means that as less light is available, you can simply turn up the ISO setting so that the camera can get a good picture without having to use a shutter speed that is so slow that it compromises sharpness (see page 78 for an explanation of the relationship between shutter speed and sharpness).

Changing ISO picture-by-picture is easy with a digital camera. Being able to change ISO on the fly as needed is a huge advantage; for example, you could be indoors using an ISO setting of 800 so that you don't need flash, and then follow your subject outside

into the blazing sun and change to ISO 100 to deal with those conditions instantly.

You change ISO on most Canon D-SLRs by pressing the ISO button and, depending on the camera model, turning the Main dial or the Quick Control dial (up or down arrow keys on the back are also used on some models). On still other Canon digital cameras, ISO is set from the Function menu.

Technically, a digital camera's ISO setting does not actually change the sensitivity of the sensor, which is why it is an ISO setting rather than a true ISO number like with film. Digital cameras adjust the "sensitivity" of the sensor circuits by amplifying the sensor signal that creates the image. This is, in a sense, like turning up the volume on your radio to better hear a station that doesn't come in very well.

Higher ISO settings will increase the appearance of noise in your images. Though Canon cameras have a well-deserved reputation for minimizing noise, higher ISO settings always result in more noise compared to lower settings, regardless of the camera. But sometimes, when shooting action or in low-light conditions, for example, higher ISO settings are useful nonetheless.

It's good to understand that different camera models have different responses with respect to the degree of noise affected by an ISO setting. Small-sensor cameras, especially the little pocket cameras, can be very sensitive to ISO change, and you will quickly notice noise as ISO settings increase from the camera's lowest setting.

Canon D-SLRs offer images with little noise at low and moderate ISO settings. And even at relatively high ISO settings, they offer excellent results. This allows you to compensate for the use of slower lenses (lenses with smaller maximum lens openings) and for shooting in low light. In Canon D-SLRs with full frame sensors, you will often get images with minimal to no noise at any standard setting and very low noise at high settings.

The best thing to do, however, is to use the lowest ISO possible for the conditions, as this will give you the best color, tonality, and resolution possible. But, it is nice to know that you can increase the ISO settings when necessary, and when you do, you are getting image quality that is actually better than what was possible with film. For Canon D-SLRs, you can easily shoot at ISO 200 or 400 and get results very similar to what you would get with ISO 100 film.

SHUTTER SPEED AND F/STOPS

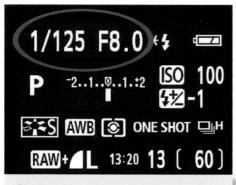

Shutter speed and f/stop settings, combined with ISO, are key to exposure. They also influence aesthetic factors like depth of field, so choose them with care.

Beyond ISO, exposure is based on the relationship between f/stops (aperture) and shutter speeds. The relationship is direct: Let more light in through the lens (f/stop) and you must shorten the amount of time it is allowed to hit the sensor (shutter speed), in order to keep exposure consistent. The camera's metering system will balance the exposure for you, but for the best image control, you need to choose a shutter speed or aperture appropriate for your subject.

It is very important to remember that these two are related. While you can choose any shutter speed, for example, you might get an inappropriate f/stop to go with it, so you may have to change your ISO setting so that you can use the shutter speed you chose and still get a good exposure.

CHOOSING SHUTTER SPEED

Choose a shutter speed based on what you need to happen in your photograph. If you are hand-holding a camera, your shutter speeds must be fast enough to limit the effects of camera movement so that your photo doesn't look blurry or out of focus (see page 78). If you need to portray action in a certain way, from perfectly arrested speed to soft blurs of movement, you must choose a shutter speed that controls that.

The speed at which your subject is moving, whether it is internal motion (such as a spinning wheel), or overall directional move-ment (like a running child), will determine the shutter speed needed to capture it. The position of the camera in relation to a moving subject also affects the required shutter speed: The same subject moving from right to left across the image area compared to moving toward or away from you will require a different shutter speed. The cross movement changes position in the frame faster than the to and from movement, therefore requiring a faster shutter speed to stop movement.

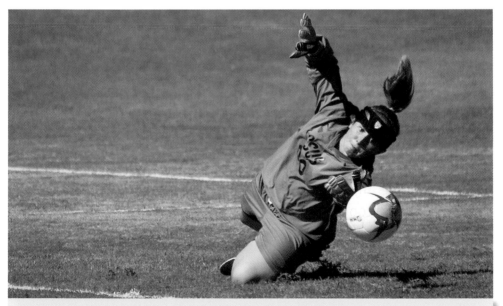

Choose the fastest shutter speeds to capture exciting action shots like this one. It might require a higher ISO setting, but a little noise is better than missing this!

The following chart offers some ideas on how shutter speed and action are inter-related. It will give you some guidelines to consider as you're choosing a shutter speed. (See page 78 for more on how shutter speed affects sharpness.)

SUBJECT SPEED	TRY THIS SHUTTER SPEED	HOW IT AFFECTS ACTION
Fast	1/1000 and faster	Fastest speeds will stop very rapid action; camera shake during exposure is rarely a problem except with very big telephoto lenses; use these speeds to allow the use of a wide f/stop for special depth-of-field effects
	1/200-1/800	These will stop moderate-speed action (high-speed action will often blur even if the rest of the photo is sharp); camera shake is rarely a problem with standard and wide-angle focal lengths
Moderate	1/50-1/160	These are not action shutter speeds as action will usually blur; camera shake now becomes a concern so good hand-holding technique is critical; telephoto focal lengths are rarely sharp at these speeds (camera movement is magnified by such lenses)
Slow	1/40 and slower	Not for stopping action, but as shutter speeds slow, blurred action becomes more interesting (though this is strongly affected by the speed of the subject); very important shutter speeds for low light and small f/stops; few people can consistently hand-hold at any of these shutter speeds and keep an image sharp

CHOOSING F/STOPS

Because f/stops seem to be just a strange set of numbers, they confuse a lot of photographers. Aperture refers to the size of the lens opening when the shutter opens and it is measured in units called f/stops. This variable is the thing that most controls the depth of field in a photograph (the sharpness from front to back) as well as the amount of light going through the lens. A big aperture (small number, i.e., f/2.8) in a lens lets through more light and gives less depth of field. A small aperture (big number, i.e., f/16) means less light and more depth of field. (See pages 94-97 for more on depth of field.)

Deep depth of field can be very important for showing detail throughout the photograph, such as in a city scene that includes a sculpture on the street in the foreground and the cityscape in the background. However, that amount of sharpness can be confusing

if you need to isolate someone in a crowd shot. In the latter situation, you often want shallower depth of field so that the individual is sharp and everything else is blurred, making it much easier to see the real subject of the shot.

Choose small apertures when you want to show a lot of background detail in a photo. The smaller apertures are, counterintuitively, represented by bigger numbers: f/11, f/16, f/22.

Keep in mind that apertures (f/stops) are relative; it helps to compare them to each other. A whole f/stop change either doubles or halves the light coming through the lens—if the aperture is larger by one stop, the light is doubled; if it is one stop smaller, the light is halved. If you halve the light via lens opening (aperture), then you must double it via shutter speed in order to get the equivalent exposure. In this way, the aperture used influences what shutter speed can be used. If you need a certain shutter speed to stop action or to create an interesting blur, then you must use the aperture that creates the right overall exposure.

The following chart illustrates the relationship between f/number, aperture size, depth of field, and shutter speed.

f/number (in whole stops)	Aperture size	Depth-of-field	Shutter speed should be
2.0		shallowest	fastest
2.8		shallower	faster
4		shallow	fast
5.6		moderate	moderate
8		moderate	moderate
11		deep	slow
16		deeper	slower
22		deepest	slowest

To further demonstrate the relationship between the three basic elements of exposure—ISO, shutter speed, and aperture (f/stop)—the following chart shows combinations of aperture and shutter speed that, at the given ISOs, would all produce identical exposures.

	ISO 100	ISO 200	ISO 400	ISO 800
f/2.8	1/1000	1/2000	1/4000	1/8000
f/4	1/500	1/1000	1/2000	1/4000
f/5.6	1/250	1/500	1/1000	1/2000
f/8	1/125	1/250	1/500	1/1000

METERING OPTIONS

The metering systems in Canon cameras have been designed with microprocessors and special sensors that give the system optimum flexibility and accuracy in determining exposure. Nearly all Canon cameras offer several methods of measuring light, including Evaluative (linked to any desired AF point), Partial, Spot, and Center-Weighted metering. On D-SLRs, these modes are set by pressing the metering mode button on top of the camera and then rotating the Main dial.

EVALUATIVE METERING

Canon's Evaluative metering system divides the image area into many zones (the exact quantity depends on the camera model) and is linked to the autofocus points as shown in the illustration to the right. The camera notes which autofocus point is active and emphasizes the corresponding metering zones in its evaluation of the overall exposure. This is an

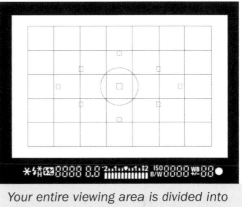

Your entire viewing area is divided into many distinct metering zones for your Canon's Evaluative metering system.

excellent metering system and produces great results with most photography. Most photographers can use this as their standard type of metering. I rarely use anything else for any of my work, from assignments to personal photography.

PARTIAL METERING

Partial metering covers about 9% of the frame (depending on the camera model), utilizing the exposure zones at the center of the viewfinder (the graph shows how parts of the viewfinder are weighted for exposure). This allows you to selectively meter portions of a scene and compare the readings in order to select the right overall exposure. This can be an extremely accurate way of metering a specific part of a scene when there are extreme variations, but it does require some experience to use it adeptly.

SPOT METERING

Available on all but the most basic EOS digital cameras, spot metering restricts the metering to a central 3.5% (approximate) of the viewfinder (the graph to the right shows that the base of the weighted "hill" is much smaller, meaning it is more restricted than Partial metering). This allows you to meter a scene even more selectively than you can when using Partial metering. For example, you can accurately meter a spot-lit subject surrounded by a totally different light. Like Partial metering, Spot metering requires some practice to master.

CENTER-WEIGHTED METERING

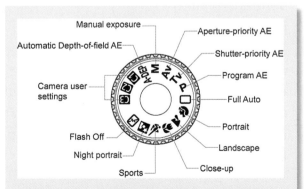

Center-weighted metering averages the readings taken across the entire scene, but in computing the "average exposure," the camera puts extra emphasis on the reading taken from the center of the horizontal frame. This is really a "legacy" metering system, a vestige of earlier Canon cameras; most photographers who still use it do so because it's what they're used to. It was designed to prevent a bright source of light, like sunshine, from over-influencing an exposure reading, but Evaluative metering will usually do the trick, and you may find it easier to use than Center-weighted.

USING THE SHOOTING MODES

Canon cameras have a choice of autoexposure modes that are divided into Basic Zone and Creative Zone modes. You will find that the more advanced the camera, the more limited the Basic Zone options will be. The highest-end pro models offer *only* Creative Zone modes, and do not feature a Mode dial; you must use a button to select the shooting mode. The Basic Zone modes are set up to simplify exposure

Manual exposure
Aperture-priority AE
Automatic Depth-of-field AE
Shutter-priority AE
Program AE
Camera user settings
Full Auto
Portrait
Flash Off
Landscape
Night portrait
Close-up
Sports

Found on most (but not all) Canon D-SLRs, the Mode dial is used to select from a number of shooting modes. The range of options available varies depending on the camera.

choices based on specific subject matter, such as action or land-scapes. The Creative Zone modes are meant to give you more control over your exposure and the resulting image. The Creative Zone includes Program, Aperture-priority, Shutter-priority, and Manual exposure modes.

CREATIVE ZONE MODES

The Creative Zone modes are the only shooting modes available on many of Canon pro model D-SLRs. You can use them to control your exposure conventionally, plus you can adjust exposure com-pensation, ISO settings, and white balance.

Program (P): In this mode, the camera chooses both shutter speed and aperture, although you can change either one and the camera will adapt to that change. This is essentially a point-and-shoot setting, as you are not required to make any exposure choices.

Aperture-priority (Av): As its name suggests, aperture (f/stop) is the key to this mode. You choose that variable and the camera sets the shutter speed to match. When aperture is critical for depth of field control, this is the setting of choice. It can also be used for action by setting your aperture to its widest (maximum) position (such as f/2.8 or f/4)—this allows the camera to use the fastest shutter speed possible for the conditions.

Shutter-priority (Tv—Time value): With this setting, you select a shutter speed for your needs, then the camera selects the appro-priate aperture. Any time you need a specific shutter speed to af-fect action, or at least want to limit the camera's ability to choose a shutter speed when you are hand-holding the camera, this is the mode to choose.

Manual exposure (M): In this mode, you must choose both shutter speed and f/stop, plus you can choose whatever you want, regardless of what the meter says. The meter does give

Many pros like to use Av for action and low light, because when you set the widest aperture in that mode, the camera will automatically use the fastest shutter speed possible given the current lighting condition and ISO setting.

an indication of what it considers to be a good exposure as you change shutter speed and f/stop. A scale appears in the viewfinder to show you how under- or overexposed the image will be. Manual exposure is needed when conditions are tricky, such as extreme lighting conditions, so the exposure can be locked into one value that will not vary as you shoot. It's also useful for overriding the exposure that the camera's meter deems correct. If you know that you want to overexpose a scene for creative effect, for example, Manual exposure is one way to do that.

A-DEP: A number of consumer-oriented Canon digital cameras have an additional mode, the A-DEP mode. This uses the power of the internal computer to quickly look at focus points from front to back in the scene, then choose an f/stop that produces a depth of field appropriate to that distance; it then chooses a shutter speed based on that aperture. While this does work to a degree and can help with depth of field, many photographers find it is not consistent enough for them to rely on regularly.

BASIC ZONE MODES

Canon's Basic Zone includes a series of camera controls that automatically set exposure and other variables for specific subjects. They limit your options, however, because they usually set ISO and white balance as well. Furthermore, many of these settings will activate the flash if the camera deems it necessary, whether you want flash or not. Still, they can be quick and easy ways of dealing with certain subjects. Here are some of them:

Full Auto: Also known as the Green mode because of the green box that designates it on the Mode dial, this option leaves all control to the camera. You cannot set anything that affects exposure when the camera is in this mode.

Creative Auto: This is sort of a hybrid between Program and Full Auto. It offers you some control over exposure, such as choosing ISO or white balance, but the camera still controls most settings.

Portrait mode: The camera chooses a wider aperture to limit depth of field, thereby keeping the subject sharp while letting the background get soft (out of focus). You'll usually get a warmer white balance setting than normal, too.

Close-up mode: This mode also selects a wider f/stop for less depth of field and faster shutter speeds, in order to ensure better sharpness with a hand-held camera; this produces a sharp subject against a softer background.

Landscape mode: In this mode, the camera favors small f/stops for more depth of field (often important for scenic shots), plus it will choose more saturated color settings.

Sports mode: The camera uses higher ISO settings for fast shutter speeds to stop action.

Night Portrait mode: This mode uses a flash exposure on the subject, combined with an overall exposure to balance the background, preserving its detail.

STRATEGIES FOR GOOD EXPOSURE

Accurate exposure is more important in digital photography than it was with color negative film, because sensors have considerably less tolerance for under- and overexposure. This limited dynamic range (or latitude), as it is called, is more than made up for, though, by the availability of a variety of tools designed to help you judge exposure. If you use all of them to their potential, there isn't any reason you shouldn't consistently get great photos that express your interpretation of the scenes you photograph.

HISTOGRAM AND HIGHLIGHT WARNINGS

If you are not familiar with the histogram, I recommend spending a little time getting familiar with it. It's very easy to understand, and it's an important tool for digital photographers.

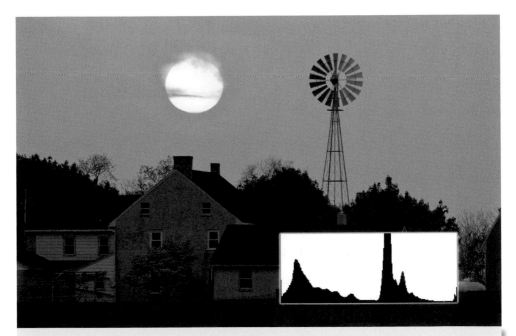

A histogram can help you get a good exposure. While it reflects the brightness values in a scene as plotted against pixels, you don't have to know anything about math or engineering to use it.

A histogram is simply a graph of brightness values of the pixels throughout your photograph. The first thing to know about a histogram is that there is no such thing as an ideal shape—it is entirely dependent on the scene. You are looking for what happens at the left and right sides of the graph, but the right side is most important. The left side represents the darkest parts of your photo, while the right side shows the brightest areas. What you want to do is get an exposure that uses as much of the histogram as possible without cutting off any graphs or leaving a large gap at the right. When the graph is cut off on either side, it is said to be "clipped."

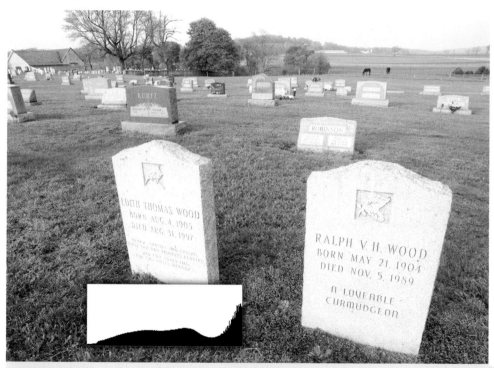

You see can by comparing this photo with the one on the right how exposure affects what is seen in the image, both in detail and color. The left image is overexposed—the right side of the histogram is chopped off, or clipped, and there is no detail in the sky, although the grass shows up nicely. The right image is underexposed—there is a gap at the right side of the histogram. While this does capture the color and tones of the sky and tombstones better, the color and tones of the grass and trees is compromised. This exposure will almost guarantee more noise in the image, too.

If it is cut off at the right, it's because there is bright detail that cannot be captured well because it is beyond the exposure range of the sensor; this may mean that the image is overexposed. On some scenes, this won't matter, such as bright parts of a photo that come from a strong backlight. But in most photos, you don't want to clip your highlights.

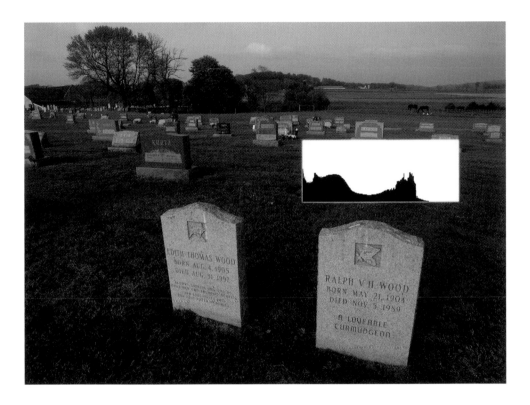

When the graph has a big gap on the right side, the image is usually underexposed. The gap means the sensor is not capturing dark details to its best capability. The picture may look okay, but dark colors will not be captured correctly and noise is going to be a problem. What is happening is that, again, the full range of the sensor is not being used. You need to give the image more exposure if you want to capture the shadow detail.

On some scenes, you will find a gap on both the right and left sides. This means the range of the scene is less than what the sensor can capture, so you will not have exposure problems as long as the gaps on the right and left are somewhat equal. This depends on the scene, however, as a dark scene may have the histogram farther to the left than a bright scene would.

A real problem comes from how some photographers use another tool for judging exposure, the highlight warnings. Highlight warnings are the blinking areas in the photo on the LCD that appear over bright areas in the image. They are meant to warn you of overexposure, but should be considered along with other factors like the histogram and how the image looks on the screen. The highlight warnings should definitely not be the only tool you use to judge exposure. It is a common misconception that the exposure is good as long as these warnings are not blinking. However, this can lead to significant underexposure and right-side gaps. These "blinkies," as they are sometimes called, can be used in such a way that you simply reduce exposure to make them disappear, but when certain highlights are unimportant for color, such as a bright light, you don't want to make them disappear.

USE YOUR LCD

Your camera's LCD can be used as a reference to check exposure. You may have heard that it shouldn't be used for this purpose, but that is not entirely true. While the LCD is not calibrated the way a computer monitor can be calibrated, you can still use it.

You have to learn what it does when it displays a photograph. It may not be exactly indicative of how the final image will look, but it does display exposure in a consistent way. While it is important to understand that the LCD may make your picture look too bright, for example, know that if this is the case, it will always render your images brighter by the same amount—unless of course you were to manually change the LCD brightness. If you just looked at such

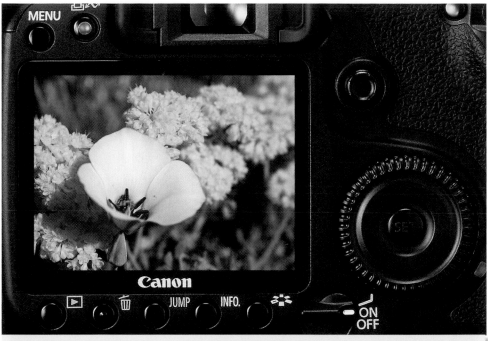

The LCD is one of the most valuable parts of your Canon because it will help you see your images as photographs so you can better evaluate your shooting.

an LCD without knowing how it displays your photos, your judgment of exposure would be way off.

Yet, if you use a camera a lot, you will get to know how it displays the pictures. You will know if it displays images too brightly or too darkly. You can then make your own mental compensation from what you see in the LCD. But, it is very important that you understand what compensation is needed by comparing what you see in the LCD with what is actually displayed on your computer screen, or what results you get when prints are made directly from your image files.

Look at all areas of your photo on that LCD, especially bright areas. Enlarge the photo so you can see if the bright areas hold important details or are washed out and empty white.

If you're not sure how to expose for a scene, use Auto Exposure Bracketing, and the camera will take a few different exposures for you.

METERING TIPS

Here are some pieces of advice to help you get good exposures and deal with common exposure problems:

◆ Don't take exposure lightly, or as something that can be "fixed" in Photoshop. You can waste a lot of time trying to fix unfixable pictures if you make this mistake.

◆ Exposure compensation can help. Canon cameras use a small +/- symbol for their exposure compensation settings and a scale with minus to the left and plus to the right. This allows you to adjust the camera to give more or less exposure than the metering system chooses. Add exposure by moving exposure compensation to the plus side; reduce exposure by moving it to the minus side.

◆ Locking exposure is another way to deal with problems. Most D-SLRs have an exposure lock button on the back of the camera, which allows you to take a meter reading from your intended subject and then lock it. Usually, you just point the camera at something brighter to decrease the exposure, or at something darker to increase the exposure, then press the lock button. You then point the camera back to your subject and the chosen composition.

◆ Try AEB. Canon offers Auto Exposure Bracketing (AEB) on many of their cameras. This allows you to set the camera to take several photos automatically, each image with a different exposure, so you can find the best exposure later. Set the amount of AEB and choose the continuous shooting setting.

◆ Be wary of underexposure if you have important middle and dark colors. Overexposure in those areas is easier to fix in Photoshop than underexposure.

◆ Be wary of overexposure if you have important bright colors. That means exposing properly to use the sensor at its best—get that histogram as far to the right as you can without clipping it!

◆ Expose for the important colors of your scene. If you have a really important color that is in only one part of the composition, for example, take a meter reading of it and use that as your main exposure. If you aren't sure you are getting the colors right, bracket your exposure (shoot variations of your exposure) to ensure that you do.

◆ Control colors with exposure. If your scene has mainly light colors, expose to make them light. If your scene has mainly dark colors, expose to make them somewhat dark (however, it is better to darken dark colors in Photoshop than to lighten them if they are too dark).

Sharpness

While sharpness is certainly affected by lens quality, it's really something much more than that. Today's Canon lenses are extremely good, from the lenses on compact digital cameras all the way up through inter-changeable lenses for D-SLRs. You will find some differences when you compare the least expensive lenses with the pro, L-series lenses, but not everyone can afford L-series lenses, and the more affordable lenses can produce excellent results, especially if you use them to their full potential.

In fact, camera technique has a larger effect on sharpness than anything else does. I have seen it happen that people who have bought very expensive lenses got results worse than those that can be produced using the least expensive kit lens for a consumer-oriented D-SLR. This occurs because a lack of attention to sharpness techniques can nullify the quality of even the best lens.

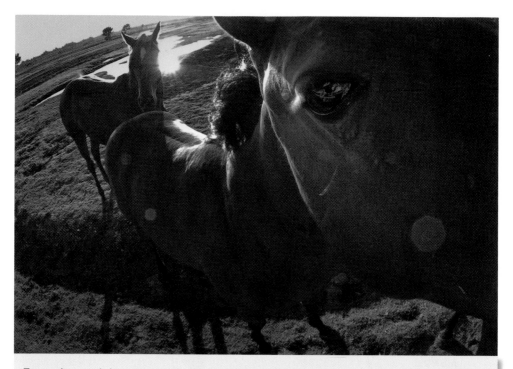

Focus is crucial to composition. The photo above shows the proper way to focus on a person or animal: The eyes must be sharp. In the example below, the flower is the subject, and the focus supports that. If the sconce on the wall behind it were in focus instead, the photograph would no longer be about the flower.

FOCUS

With the capabilities of autofocus today in Canon's cameras, it is easy to take focus for granted. Yet, a perfectly sharp picture can be all wrong if the focus isn't in the right place.

For best sharpness in a photograph, you need to start by being sure that your camera is focused on the right part of your subject. A portrait that has its focus on the ears, a close-up of a flower with the focus at the back of the flower, and a telephoto shot of

soccer action that is focused on the wrong player are all examples of misplaced focus.

Canon cameras will show you where they are focusing by lighting up focus indicators inside the viewfinder. Watch where these show up on your subject and in the scene and be sure that point of focus is where you want it.

If focus is really important, then be sure to check it in the LCD. The latest LCDs on Canon cameras are large and full of detail, but when checking for critical focus (the plane that is optically in focus), you should enlarge the picture to see exactly where the focus is. Here are some things to consider about critical focus:

◆ **Focus on the eyes.** It doesn't matter whether you are photographing a person, a dog, or a grasshopper, if your subject has eyes, they need to be sharp.

◆ **Focus on the most important part of the subject or scene.** If there are details that must be seen, then they must be in focus.

◆ **What is your photograph about?** Make sure your focus supports that idea.

◆ **Watch for shifts in autofocus.** You may think that you have the right thing in focus, but the camera may shift focus just before you take the picture.

AUTOFOCUS (AF)

Autofocus technology is pretty amazing in and of itself, but beyond that, Canon is constantly improving the precision and accuracy of its AF detection. Autofocus works by detecting contrast, using multiple detection points within the image area to automatically find the focus. So in theory, having a system that gives it more opportunities to detect that contrast (i.e., containing more of those detection points) will improve its accuracy. The number of points

varies from camera model to camera model, ranging from seven basic points on the inexpensive D-SLRs (usually including a center, cross-type sensor) to 45 cross-type and AF-Assist sensors on the high-end pro models.

The DIGIC 4 is the most recent iteration of Canon's image processing chip. It offers improved AF in Live View mode, among other improvements over earlier versions.

Most camera models offer a number of AF modes to choose from, including: One-Shot AF, AI Servo AF, and AI Focus AF. Manual focusing is also an option and easy to switch to on Canon D-SLRs: Just flip the AF/MF switch on the lens.

Some people may prefer to use AI Focus AF for a subject that moves intermittently. Be wary of that, though, because in the above photo, for example, if a breeze came along and caused the grass to move, AI Focus might mistake that for subject movement and activate AI Servo, even though the subject itself is still.

Cameras handle autofocus functions using a high-performance microprocessor built into the camera. Cameras today have the ability to very quickly employ statistical prediction while using multiple focusing operations to follow even an erratically moving subject.

When light levels are low, most cameras activate an AF assist—the built-in flash or external dedicated flash will produce a series of quick flashes to help the autofocus system "see" contrast, so that it can focus more effectively. The range of the assist from a built-in flash is somewhat limited and will only go out to about 12 feet.

CHOOSING AN AF MODE

Your Canon camera will have up to three AF modes in addition to manual focus. You choose these when the camera is set to one of the Creative Zone modes. In the Basic Zone modes, the AF mode is set automatically. Typically, pressing an AF button accesses them, then you use a dial or control button to scroll to the mode you want to use.

One-Shot AF: This AF mode finds and locks focus when you press the shutter button halfway, and is perfect for stationary subjects because it allows you

I selected the One-Shot AF mode for this architectural shot. If I had wanted to capture the movements of a street performer in front of the building, however, AI Servo would have been the better choice.

Always use AI Servo AF, along with a continuous drive mode, for the best results when you want to freeze action.

to find focus and hold it at the important part of a subject. If the camera doesn't hit the right spot, it is a simple and quick matter to slightly change the framing and press the shutter button halfway again to lock focus where you want it. Once you have found focus and locked it, you can then move the camera to set the proper composition. The focus confirmation light will glow steadily in the viewfinder when you have locked focus, or it will blink if the camera can't achieve focus.

AI Servo AF: Great for action photography, AI Servo becomes active when you press the shutter button down halfway, but it does not lock focus. It continually looks for the best focus as you move the camera or the subject travels through the frame. When you are using AI Servo AF on a moving subject, it is a good idea to start the camera focusing (depressing the AF-ON button) before you actually need to take the shot so that the system can find the subject.

AI Focus AF: This mode allows the camera to choose between One-Shot and AI Servo. It can be used as the standard setting for the camera because it switches automatically from One-Shot to AI Servo if your subject starts to move. Note, however, that if the subject is still (like a landscape), this mode might detect other movement (such as a blowing tree), so it may not lock on the non-moving subject. I recommend making a distinct choice of either One-Shot or AI Servo AF for each specific situation. That way, you should be able to get consistent results.

SELECTING AN AF POINT

You can have the camera select the AF point automatically, or you can manually select a desired point. The autofocus point selected determines in which part of the scene the camera looks for focus. So, if you are selecting the point manually, select the one that is where your subject is in the frame. If you've set the camera to

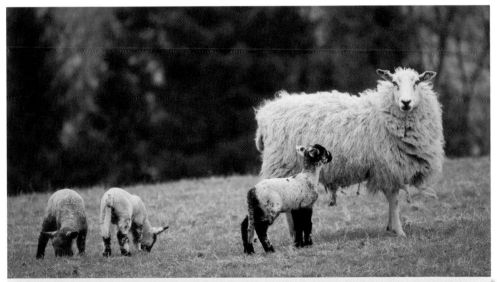

Automatic AF point selection worked just fine for this shot, because there wasn't much in the scene that the camera could have focused on other than the sheep. But, if there had been a tree right behind them, for example, I may have needed to select the AF point manually to ensure that the camera focused where I wanted it to.

do it automatically, it will look for what is likely to be the subject (i.e., the closest object or something that is close to the center of the frame), and look for contrast there in order to focus. For this reason, manual AF point selection is useful when you have a specific composition in mind and the camera won't focus consistently where you want it to.

Canon cameras do vary as to how you go about manually selecting an AF point. Look for an AF selection button (it usually has a cross of dots or some other dot pattern). Push the AF point selection button and use the dial, Multi-controller, or control buttons to select a focus point. Points light up in the viewfinder or on the LCD as they are selected. Generally, if you push the control to select an already lit point, the camera automatically selects them all.

The autofocus points will appear over the image area in your viewfinder, and the one in use will be illuminated in red. The number and type of points vary depending on the camera model.

AF LIMITATIONS

AF sensitivity varies from camera model to camera model, and Canon is constantly working to make the sensitivity better and better. Still, autofocus does have its limitations, one of which having to do with your lens' aperture. All autofocus cameras, when they are focusing, do so with the lens set to its widest opening, or largest aperture, and do not close down to taking aperture until you fully depress the shutter button to take a photo (or if you press the Depth-of-Field Preview button). So, the smaller the

A scene like this one could present problems for autofocus because of the glare from the sun and the backlight. Autofocus has trouble with bright light as well as scenes with low contrast or a lot of horizontal lines. You may have better luck shooting scenes like this by pointing the camera away from the sun to lock autofocus, then reframing for the proper composition. Or you may need to use manual focus.

maximum aperture of the lens you're using, the more limited the camera's autofocus capabilities.

On most cameras, AF works its best with f/4 and faster lenses, and its function may be severely reduced at f/stops smaller than f/5.6. When you add a tele-extender to your lenses, this will also reduce the amount of light going into the camera and onto the AF sensor. This can even prevent your autofocus from working at all. It is important to realize that this is normal and not a problem with the camera. You are just going to have to use manual focus in these situations.

It is possible for AF to fail in certain other situations, too, requiring you to either focus manually or improvise a little. This would be

most common where the scene is low-contrast or has a continuous tone (such as sky), in conditions of extremely low light, with subjects that are strongly backlit or have glare behind them, and with compositions that contain repetitive patterns. A quick and easy way of dealing with these situations is to move the camera to focus on something at the same distance as your subject, lock focus on it, then move the framing back to the original composition.

MANUAL FOCUS

Manual focus requires you to focus the lens so the subject is sharp, but autofocus is so good today with Canon cameras that you will not need manual focus very often. There are some situations, however, in which manual focus is the more appropriate choice because autofocus will not work very well; this can happen with subjects that have bright lights around them, scenes with strong horizontal lines, and in low-contrast conditions. In addition, when you are close to a subject, the camera may pick the wrong spot on that subject to focus, so you must often use manual focus in this situation too.

Be aware, however, that autofocus often produces more accurate and faster results than manual focus. Many photographers perform manual focus slowly and methodically, but studies have shown that focusing is more accurate when done quickly, whether via auto- or manual focus. That's because neither the photographer (in the case of manual focus) nor the camera (in the case of AF) can see very well what is in or out of focus when the focus changes slowly, because it occurs in such small increments. When it changes abruptly, which is how it works with autofocus, the difference between in and out of focus is quite apparent. Unless you are a practiced pro, you will find that autofocus works much faster than you can turn the manual focusing ring while searching for focus, so, with the exception of close-up shooting, you'll frequently get better results with autofocus.

To get perfect focus on an extremely close-up subject, try switching to manual focus, focusing the lens until the subject appears to be more or less in focus, then move the camera and lens to and from the subject until the critical parts are sharp.

If your camera has Live View (real-time view on the LCD screen, like on point-and-shoot cameras), you might be inclined to use it to check manual focus before you take your picture. This can be very helpful if you're using a tripod and your particular camera's Live View offers the ability to zoom in on your subject to really see if it's focused. Live View can also be a great tool for manually focusing in close-up shooting. In other situations, however, I cannot recommend using Live View to help with manual focus—it simply does not offer the kind of accuracy that Canon's autofocus systems consistently provide.

To activate manual focus, you simply flip the AF/MF switch on the lens to MF; this immediately switches the camera from AF to MF. In addition, some L-series lenses let you focus manually while the lens is set to AF.

CLOSE-UP FOCUS

When you move in close to your subject, focus becomes especially crucial. A change in focus of fractions of an inch can make a difference between good focus and bad focus. This is where autofocus can cause you problems. Up close, there can be many places within a very narrow space for the camera to potentially focus, so the camera may not know where to focus. Often, you will find the camera focuses behind your subject.

There are a couple of ways around this. The first thing is simply to change from autofocus to manual focus. That way, you can be sure you are focusing on exactly what you want. You will find it easier to focus manually, however, if you first get an approximate focus by turning the lens' focusing ring, then move your camera in and out from the subject until it is in focus. The reason for this is that as you change focus on the lens when you are focusing up close, the size of the subject changes too, making it harder to see the focus change. When you set up focus and move back and forth, the subject's change in size is not as dramatic.

You can do a similar thing with autofocus. Get in close and lock focus on your subject as best you can. Then move the camera back and forth until you have the right point in focus, all the while keeping your focus locked.

Another problem with close-up photography is the moving subject. It can be hard to make sure that your focus is always in the right spot. A helpful trick in this case is to set your camera to a continuous drive mode, put your lens on manual focus, get an approximate focus, and then hold down your shutter release as you take a burst of exposures. Usually, you will find that at least one of these exposures will be in proper focus.

CAMERA MOVEMENT/CAMERA SHAKE

The number one cause of unsharpness is camera movement during exposure. Even the best quality lens can be reduced to a very poor showing by camera movement. When camera movement affects an image, the problem is pretty obvious—the picture looks fuzzy.

Camera movement or shake during exposure can be much more insidious than that, however. At low levels, it will reduce contrast of an image and remove what is called image brilliance from a scene. *Image brilliance* is related to how a lens captures tiny highlights. The best lenses will capture them very crisply,

Use a tripod or a faster shutter speed to prevent unsharpness from camera shake. The bottom photo demonstrates how camera shake can affect sharpness if you don't take one or more of the precautionary measures laid out in this section.

but camera movement will blur those tiny highlights, reducing image quality. This sort of effect can be relatively unnoticeable when a photograph is small, such as a 4 x 6-inch print, but it can be very disappointing when you want to make a big print and it looks soft.

There are three factors related to camera shake that can affect sharpness: shutter speed, how a camera is held, and whether or not you use added camera support. The only way to know for certain how a particular shutter speed can affect sharpness is to shoot a subject at that shutter speed while you hand-hold the camera, and then a second picture with all the same settings from a tripod. I have done tests with people and found that very few photographers can match the tripod at shutter speeds less than 1/125 second when hand-holding the camera. This is with normal focal lengths; telephoto lenses will require even higher shutter speeds.

There is an old rule that says you need to have a shutter speed equivalent to or faster than 1/focal length for sharp pictures when hand-holding a camera. For example, if you were using a 200mm lens, you would need 1/200 as a minimum shutter speed. This rule is pretty good, except it applies best to full frame (35mm) sensors. If you're shooting with a camera that has the smaller APS-C size sensor (as many Canon digital cameras do), then you need to use the next faster shutter speed. Some Canon lenses offer Image Stabilization, which changes these rules a little bit, offering you a stop or two of leeway. (See pages 191-192.)

Cameras are designed to be hand-held in one way. Grip the camera with your right hand so that your forefinger rests on the shutter button. Turn your left hand so that your palm faces up, and place the camera into that palm. If you're holding the camera horizontally, its base (bottom) will be in your left hand; if you're holding it vertically, its left side will be in your left hand. If you're using a big lens, place the lens into your palm. Now make sure your elbows are tucked into the sides of your chest. Finally, gently squeeze the shutter button—never punch it.

TRIPODS AND OTHER SUPPORT

The ideal camera support is a tripod, though monopods and beanpods can help, as can bracing the camera against something

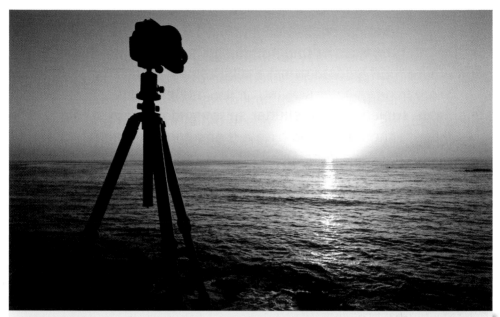

A good tripod and head are critical to sharp images in many situations. They are a good investment that can result in sharper images, even more than buying a high-end lens. A low-priced lens will often outperform a better one when used with a tripod.

solid. If you aren't using a tripod, you either never shoot in conditions demanding slower shutter speeds or you are living with images that are not as sharp as they could be. I can guarantee that an inexpensive lens shot on a tripod will consistently beat the most expensive, highest-rated lens that is never used on a tripod. If you want to get the most from your equipment, then at some point, you will need a tripod.

Choose a tripod by setting it up at the store, locking down the legs and leaning on it. It should not bend or sway significantly; any movement more than a few millimeters means a less-than-stable tripod, which will not give you sharp images. Both metal and carbon fiber tripods are excellent. The advantage of metal is low price, while the advantage of carbon fiber is that it is lightweight and stiff.

A tripod also needs a sturdy head to go with it. Pan/tilt heads have many levers to lock and unlock compared to the single main

Ballheads are more expensive and can be harder to control than the pan/tilt type, but ultimately offer faster and more flexible control once you get used to using one.

knob or lever of a ballhead, but the pan/tilt heads offer two advantages: lower price for equal stability, and easier to set a camera into position without the camera and lens taking off on their own.

The ballhead is much more convenient for setting camera position, but since the lock loosens all dimensional movement, there is more potential for sudden change in unexpected directions. Small ballheads (with tiny balls) are not very rigid or useful for stabilizing a camera. You can get very lightweight, yet large enough, ballheads. Buy a ballhead with a quick release, then get extra release plates for all tripod sockets on your cameras and lenses. Quick releases make tripods so much easier to use.

ACTION PHOTOGRAPHY

Canon cameras have been steadily engineered to do better and better with action. This was once a challenge with digital cameras because action happened too fast for the cameras to respond. Now, you can follow action at 10 frames per second (fps) at bursts of 110 shots at a time with the most recent pro-model D-SLRs. Even moderately priced Canon D-SLRs can do up to 6 fps at bursts of 90 shots at a time. Furthermore, autofocus works quickly enough on most of Canon's D-SLRs that it, too, will keep up with a moving subject. Certainly, with the more consumer-

oriented cameras, you may need to employ some of the methods set out below to deal with fast action.

AUTOFOCUS AND ACTION

Action can be a challenge for autofocus. A moving subject means that the camera has to find the subject, focus on it, and then track the movement to keep the subject in focus, all the while taking pictures as the photographer presses the shutter release.

This is why certain cameras, such as the Canon EOS 1D Mark III, are designed specifically for speed. Most Pro D-SLRs have AF systems optimized for action. If you shoot a lot of action and action photography is important for you, you may need to look into these cameras.

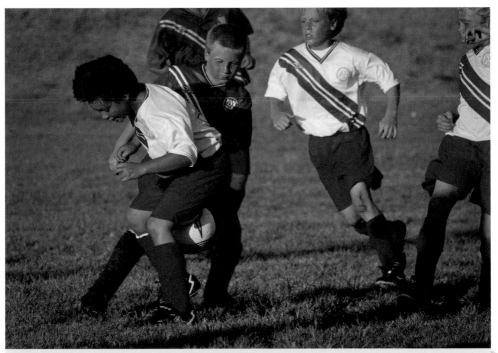

Pro-model and mid-level D-SLRs generally do better for sports and other action than the entry-level consumer models. However, check out the tips on the next page for getting great action shots with any camera.

You can, however, use any Canon camera and its autofocus for action if you understand how to work with its limitations. Here are some things to try:

Start your autofocus early: Press the shutter lightly to get the autofocus going before you need to capture the shot. This is really important; otherwise, your camera will only be starting to focus when you need it to be taking pictures. Some Canon D-SLRs have a Custom Function that allows you to assign focus to a button on the back of the camera (usually the AF-ON button). Many sports photographers use this to start AF before they need to shoot.

Use the AI Servo AF setting: On many cameras, you will have a choice between One-Shot and AI Servo AF. One-Shot will only take a picture when the camera thinks the subject is in focus. AI Servo lets you take pictures whenever you want as long as the camera's buffer keeps up.

Know your camera: Take a lot of pictures with your camera on autofocus. You need to know what your camera can and cannot do with certain types of action.

Anticipate action for AF: If you know a certain action is likely to occur in one location, point your camera there and press your shutter to "pre-focus" in anticipation of that action.

Turn off AF when needed: Sometimes you will find that your camera's AF just can't cut it for a specific type of action. You may need to turn the autofocus off. This will prevent the camera from suddenly searching for focus at the wrong moment. It can also help slower cameras be ready for action if they don't have to auto-focus in addition to metering.

Know your subject for better action shots: The number one way of getting great action shots is to know the subject. The more you know the subject and the characteristics of its action, the better you will be able to capture it.

There is no area where this is more evident than sports. I can guarantee that if you don't know the sport, you will find it difficult

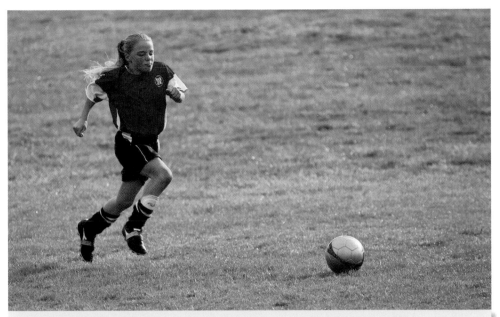

Know the sport, be familiar with how the subject moves, and know your camera's capabilities and limitations to get consistently good sports photographs.

to get good action shots, and anyone who really does know the sport is going to get consistently great action photos. You have to know a little about how the game is played, and watch it enough that you can start to predict where certain action will occur. You need to know when a runner on first might try to steal second or how a quarterback deals with a pass rush.

Knowing your subject is important for any activity. Wildlife can be a very active, difficult-to-cature subject. The reason why action shots of wildlife are so dramatic and full of impact is in part because they are so difficult to get. You must understand something of the animal you are photographing in order to be there when the action happens.

SHUTTER- VS. APERTURE-PRIORITY FOR ACTION

Autoexposure is great for action because it adjusts to compensate for different lighting conditions as the action moves in and out of shade, for example. The disadvantage is that dark or bright

backgrounds can throw it off, but if you check your histogram occasionally, you can adjust for that.

When shooting autoexposure for action, select Aperture- or Shutter-priority mode. In cases where you need a very specific shutter speed, Shutter-priority is the way to go. You select that specific speed and the camera chooses the appropriate f/stop for it.

In many cases, Aperture-priority is a better choice for action because you can always ensure the highest possible shutter speed for any given shot. Set the lens to the widest f/stop, the maximum aperture available (the smallest number). To compensate, the camera will always use the fastest shutter speed possible for the conditions and will continue to do so as the light changes.

You can also use the Sports mode if your camera has it. This auto setting will try to keep shutter speeds high, but the drawback is that it will also increase the ISO setting whether you want it set higher or not.

ACTION AND SHARPNESS

Any representation of movement in a photograph has to be an interpretation, because you cannot show actual movement in a photograph. There are three basic ways of interpreting action in a still photograph: stopping action, blurring movement, and combining both in the same image.

Stopping action: The most common way of dealing with action photographically is to freeze it. But, to be effective, a photograph of stopped action must really show that action stopped. Any slight blur takes away from the sharpness effect that creates the drama of frozen movement.

You'll only be able to freeze action in a photograph if the shutter speed is fast enough to capture it. If the shutter speed is too

slow relative to the action, say 1/125 second for a racecar travelling at 110 mph, the subject will blur across the frame, instead of being captured sharply. This relationship between movement and shutter speed is highly dependent upon the subject, as well as your angle and distance to the subject. So, fast subjects need faster shutter speeds. Some subjects, such as a hummingbird flapping its wings, may require a faster shutter speed than you have available on your camera. Others, such as a snail in your garden, can use a much slower shutter speed—slow enough in fact that you're probably more likely to get unsharpness due to camera movement than from the movement of the snail.

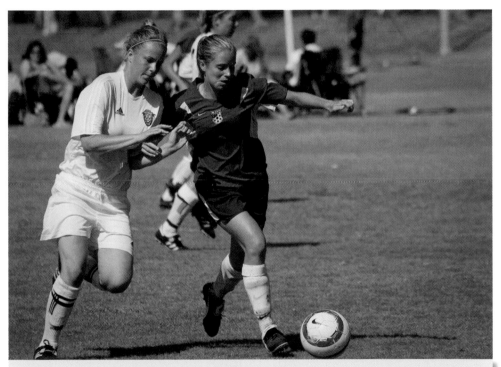

I used a very fast shutter speed (1/1500) to be sure the action was completely frozen in this photo. Had I used a slower shutter speed, like 1/90, the action would have blurred a little, which just wouldn't show the drama of the moment the way this shot does.

Here is a chart that will help you choose shutter speeds for action:

Shutter speed should be	Angle to Subject's Movement	Distance from Subject	Speed of Action	Example Shutter Speeds for Action
Slower	Same axis	Farther away	Slow	1/60 & slower
↑	↑	↑	↑	1/125-1/250
↓	↓	↓	↓	1/500-1/1000
Faster	at 90 degrees	Closer	Fast	1/2000 & faster

◆ **Shutter speed needs to be:** This part of the chart shows you that you can use longer (slower) shutter speeds in one direction and shorter (faster) in the other, all in relation to the other elements of the image, such as the angle to the subject, distance and speed of action, etc.

◆ **Angle to subject's movement:** As you change your angle to the subject's movement, you need to adjust your shutter speed. A runner heading right toward you, for example, can be captured sharply with a slower shutter speed than one that is crossing right in front of you from left to right. You always need the fastest shutter speed when action is going across your field of view, parallel to the back of your camera.

◆ **Distance from subject:** the closer you are to a moving subject, the more apparent the movement, because a closer subject moves farther across the image area than a distant subject travelling at the same speed. With distance, you can get away with slower shutter speeds, but a closer moving subject will require shorter ones. Be very aware of this when action is moving fast and close; use the fastest shutter speeds possible then.

◆ **Speed of action:** Obviously, the faster the action, the faster the shutter speeds you need. A running dog is going to need a much shorter shutter speed than a strolling cat, for example.

◆ **Example shutter speeds:** In the chart are examples of shutter speeds that might be used in different conditions. Use these as a guide in choosing a shutter speed, but not as a rulebook. You always have to adapt your choice to the conditions of the action.

ACTION AND UNSHARPNESS

A completely different way of dealing with action and movement is to not stop it at all, but to let it blur into moving strands of color and form. Motion blur gives a feeling of movement and speed that a sharp action photo does not. Or, you can follow the moving

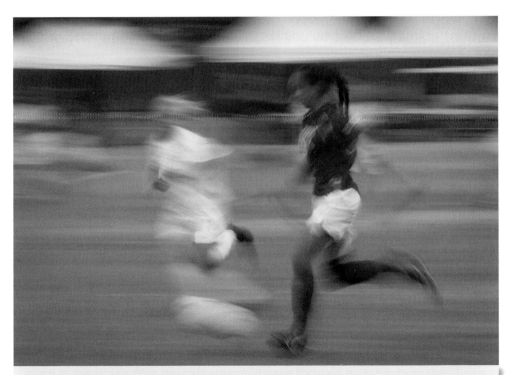

Action can show a real sense of speed and movement when shot at a slow shutter speed. The exact speed to use is very subjective and depends on the speed of the action. Try different shutter speeds and compare the results.

subject with the camera—panning is a way to capture the moving subject relatively sharply, but with some blur in the background, which, like motion blur, conveys a sense of movement.

Motion blur: Motion blur is an important tool for the photographer; it allows expression of movement that cannot be done in any other way. Motion blurs can be difficult because you cannot predict them; you can only experiment and try different exposures until one works for you. Use your LCD; try taking a photo at a particular shutter speed and see what it looks like.

A very common way of using motion blur is to shoot water with slow shutter speeds. This gives a smooth look to water and shows flow patterns.

One thing to consider when choosing shutter speeds is this: Do you want partial blur with recognizable features, or complete blur with soft colors and no edges (in the moving portion of the image)? This is totally affected by shutter speed and the speed of the movement. You generally want enough blur that the viewer knows you wanted that effect. As the shutter speed slows down, the subject will become less and less recognizable until it becomes a shadowy color form, important for the color and flow more than the actual subject itself.

To get a good exposure with slower shutter speeds, start by selecting the smallest f/stops on your camera (f/16, f/22, for example) and a low ISO. If there's still too much light for the shutter speed you want, you can also reduce the light to the sensor by adding dark filters in front of the lens. Try a polarizing filter, which takes out about two full stops of light. This is also where a neutral

density (ND) filter might come in handy. You can get them in very strong densities that will reduce the light by three stops or more.

Contrasting sharpness and unsharpness in the same photo: Action photos make a lot more sense visually if there is an unmoving element in the scene to contrast the moving subject; this contrast will create a sense of balance and "ground" the photo. The easiest way to do this is when you want to shoot a moving subject, look for something that is still and find a way to include it in the image frame. Rocks, for example, provide a good grounding element for those running water photos; this also works for moving waves in big water. Also, look for other things that aren't moving, such as a tree or some driftwood on the shore.

Get creative—there are a lot of ways you can use this idea; think about a track meet as sprinters blur past the timers with stop watches, the latter perfectly still watching the finish line. Or, a busy street corner with flowing people all around a stationary street vendor.

Another way to combine sharpness and blur is to use flash with a long shutter speed (slow sync, or flash blur). The flash gives a sharpness to the subject, while

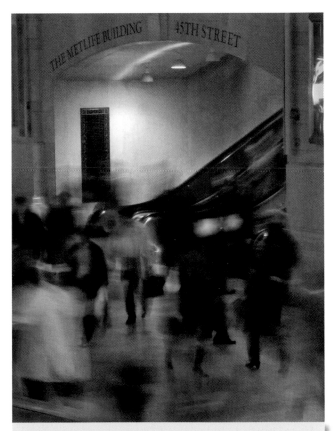

If you have something sharp in a photo with blurred action, it provides an interesting contrast that can convey a sense of movement.

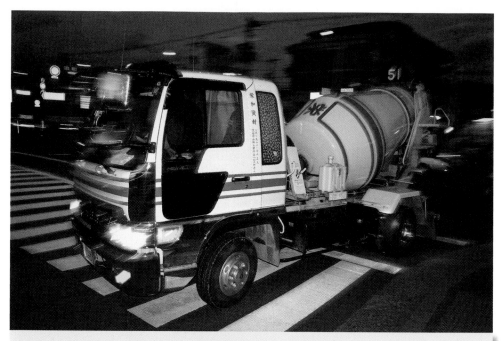

Combining flash with a long shutter speed can create an image that is both sharp and blurred at the same time. The flash will create a sharp image, while the long shutter speed will give the blur.

the long exposure blurs movement. The result is a sharp image of your subject, with blur surrounding any moving elements in the scene—this may even include part or all of the subject itself. Put the camera on a tripod so that anything that isn't moving is sharp. This can be used with all sorts of moving subjects. Yet another way to do this is to shoot hand-held so the flash image is still sharp, but everything else is blurred from the combination of the long shutter speed and the camera being hand-held.

The easiest way to do slow sync with Canon cameras is to set the camera to Aperture-priority when using flash. The autoexposure will give a good exposure for the existing light combined with the flash. Use an aperture setting that will give you a shutter speed slow enough to blur the subject. (See pages 251-252 for more on slow sync.)

Panning: Panning is a great technique to use with subjects that are moving through an area, such as a runner, a bird, or a car. You simply move the camera with the subject as it moves, taking the picture as the camera is moving.

With very fast subjects, this can be the only way to get them even remotely sharp. Panning with the subject makes it "slower" in relation to the camera, so a relatively slow shutter speed can freeze its action. The background, however, will usually not be sharp because the camera is moving across it.

Very interesting effects come from using slow shutter speeds with panning. With each slower shutter speed, the background blurs more, until it becomes streaks of color and tone. Slow the shutter speed even more and the subject itself starts to blur, first along the moving edges, then over the whole thing. There is a whole range of interesting possibilities as you change shutter speeds.

It is important that you move the camera continuously through the exposure. Start panning the camera with the subject before you

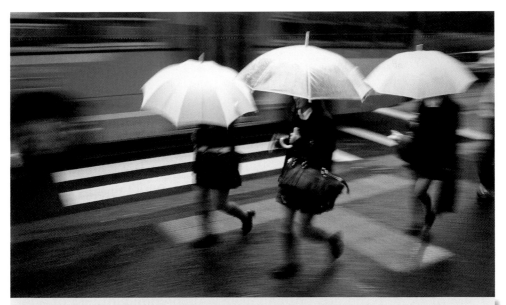

You can mix panning with motion blur to get some really interesting results. I panned the camera with the subjects to maintain some sharpness, but also used a slow shutter speed to show some of their movement.

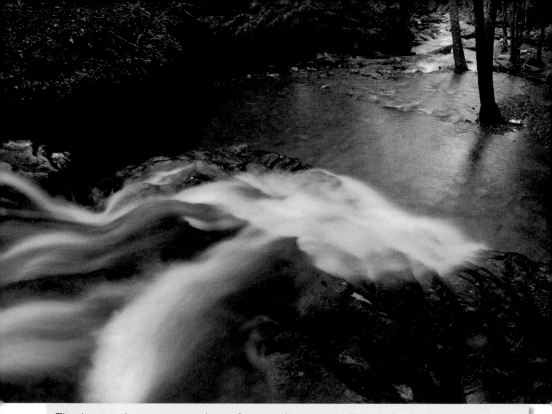

The longer the exposure, the softer moving water will look. Long exposures remove the element of fast action detail and blend it together into flow patterns that define the moving water.

press the shutter, then keep moving the camera even after the shutter has closed. Don't stop suddenly because you will get odd patterns in the blurs from that.

SUBJECT TIPS: Here are a few hints to get you started experimenting with motion blur and panning.

1. Running water: Water blurs give that streaming look starting at about 1/2 second of exposure. Longer exposures blur the water more, until it starts taking on a milky look at several seconds.

2. Waves on big water: Waves blur to interesting patterns, and breaking waves have a mist-like appearance with long exposures. Waves on big water need very long exposures to get interesting results. You'll find that several seconds is usually the minimum, and that long exposures of 10-20 seconds or more can give the most interesting results.

3. People at walking speed: You can get some nice blurred effects at around 1/4 – 1/8 second, especially if you pan with the subject. Longer shutter speeds will create interesting patterns, sometimes even the effect of "ghosting" of parts of the body will occur (it appears transparent or disappears altogether).

4. Running people: Runners require faster shutter speeds than walkers, and panning is almost always the best way to go. Try speeds starting around 1/8 – 1/15 second, then experiment with slower speeds.

5. Dancers: You can get some incredible effects with dancers at slow shutter speeds. Start with 1/4 – 1/8 second and then experiment with slower speeds until you find something you like.

6. Running animals: Animals at speed make for great pan-blur shots. Try 1/4 second with panning to start, then go faster for faster animals, slower for slower animals. Speeds as fast as 1/15 second can be very effective with animals with fast moving legs and a lot of up-and-down movement.

7. Night street scenes: Long exposures give fascinating streaks of light from cars. Set up your camera for an interesting night scene with the road going through the

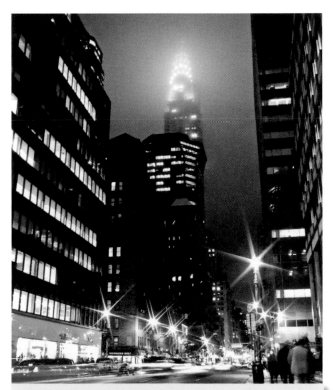

Blurred lights of traffic make a great foreground for a nighttime city scene, showing both the movement of the traffic and the still architecture of the city.

composition. Wait for a set of cars to come and start your exposure just as they reach your image frame. You will see white streaks from headlights, red streaks from taillights. Generally, you want an exposure that will let at least some cars go completely through the scene or you will get chopped-off streaks.

8. Fast cars: A classic shot for high-speed automobile racing is the panned shot with the car sharp and the background blurred. You need to have a shutter speed fast enough to give good sharpness to the car, yet slow enough to provide interesting blurs to the background. Try something around 1/15 – 1/30 second to start.

9. Blowing leaves: Another interesting use of blur is to photograph trees and grass in the wind. You can get some great patterns, colors, and tones. Shutter speed is entirely dependent on the wind—on a very windy day, a speed of 1/2 second might be plenty, whereas you may need a full second or more to capture some motion if there isn't much wind.

10. Fireworks: Fireworks are a great subject for motion blur. In general, you want an exposure long enough to allow the fireworks' colorful streamers of light to show up as a nice pattern. Typically, several seconds is about right.

DEPTH OF FIELD

Depth of field refers to the amount of apparent sharpness in front of and behind a photo's plane of critical focus. A photograph in which nearly everything from the front of the scene all the way to the back appears sharp is said to have a lot of depth of field. Conversely, if the plane of focus is very shallow—the center of a flower for example—and everything in front of and behind that point appears blurry, that image is said to have little, or shallow, depth of field. The following factors affect depth of field:

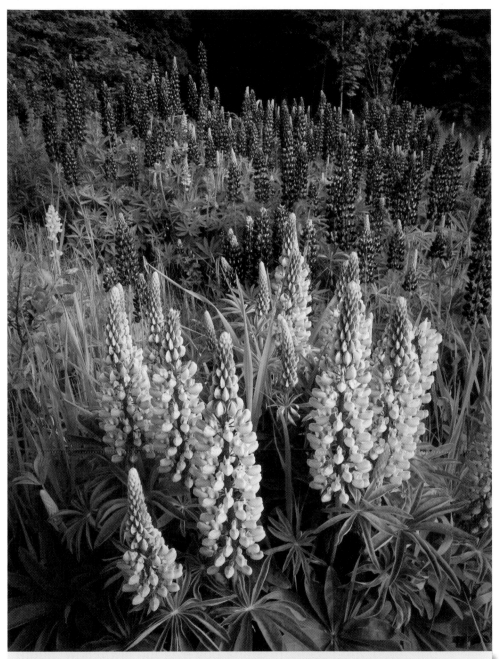

A number of factors determine depth of field. I shot these flowers using a wide angle and a small aperture in order to maximize the depth of field.

APERTURE (F/STOP)

A small aperture creates deep depth of field, while a wide (or large) aperture reduces it. Besides controlling the amount of light that reaches the sensor during a given exposure (as discussed in Chapter 2), aperture is a creative control in photography. If you want your background to be more clearly seen behind your subject, you need a small aperture for more depth of field. If you want that background to be less dominant and somewhat out of focus, select a wider aperture for less depth of field. (Refer to pages 48-50 for a more in-depth explanation of aperture.)

FOCAL LENGTH

The shorter the focal length of a lens, the greater the apparent depth of field. Conversely, as you increase the focal length of a lens (i.e., zoom in), depth of field decreases. If you want your background to be more clearly seen behind your subject, try a wider-angle focal length. If you want that background to be less dominant and somewhat out of focus, change to a longer focal length.

Landscape photographers often shoot with wide-angle lenses to gain more of a feeling of depth (from perspective) and sharpness (from more depth of field). Portrait photographers will typically do just the opposite—shoot with a telephoto lens to make the subject stand out from the background as a result of less depth of field.

FOCUSING DISTANCE

Camera-to-subject distance changes depth of field; a close focusing distance will make depth of field shallower, while being farther away makes it greater. This is why close-up or macro photography can be challenging for sharpness: Depth of field is shallow no matter what you do. On the other hand, you can focus on mountains in the distance and not worry much about depth of field; they'll probably be sharp no matter what aperture or focal length you use.

All of these work together, of course—f/stop, focal length, and distance. The shallowest depth of field comes from a wide aperture used on a telephoto lens at a close distance. The deepest depth of field comes from a small aperture used on a wide-angle lens at a long distance. An extreme example of this is hyperfocal distance, the combination of settings that provides apparent focus into infinity—from somewhere in the front of the scene to as far back as you can see in the image (and beyond that, in theory) is in apparent, acceptable focus. Although the plane of critical focus (where the actual focus is) still exists, you can see little or no difference between it and the rest of the image in terms of focus.

The chart below illustrates the relationship between depth of field and the factors discussed in this section.

Depth of Field	Aperture (f/stop)	Focal length	Distance
	Wide (e.g., f/2.8)	Telephoto (e.g., 105mm)	Close
⬆ Less More ⬇	⬆ ⬇	⬆ ⬇	⬆ ⬇
	Small (e.g., f/16)	Wide-angle (e.g., 28mm)	Far

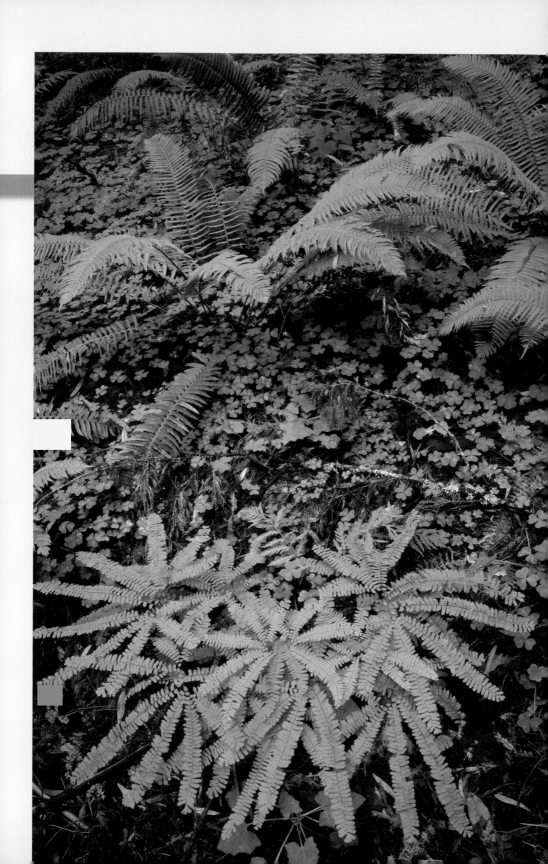

4 CHAPTER

White Balance

Though colors look natural to our eyes in most situations, various light sources have different color temperatures, and cameras do not adapt to them like our eyes do. Rather, they interpret the color objectively; for example, incandescent is a very warm light (yellowish-orange) and that's how the camera captures it. So, you must set the white balance (WB) on your camera in order to balance the way the sensor captures the light with the color temperature of the light in the scene. This will ensure that the colors in your images look natural.

The basic (or preset) WB settings are simple to learn, and selecting the most suitable one should become part of the photography decision-making process (unless you use mainly automatic settings). The more advanced Custom white balance is also a valuable tool, used for rendering the truest color in even the most challenging conditions.

The Auto white balance setting directs the camera to evaluate a scene's color and light, then balance it to neutral daylight. This makes white balance "easy," but it can also give you inconsistent results because Auto constantly reevaluates and changes the setting.

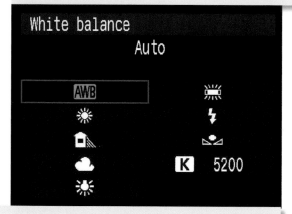

The Auto setting directs the camera to evaluate a scene's color temperature and balance it to neutral daylight. This is technically helpful, but can take creative control away from the photographer.

White balance is set by pressing the WB button on your camera, then using the control dials or buttons to change the setting. You will see the WB settings as they cycle through the options on the LCD panel or screen (which one depends on the camera model). The easiest way to use a white balance setting is to simply match the type of setting with the conditions of the scene, e.g., the Sun setting with a sunny day or the Cloud setting when it is overcast. I'll get into some more creative and technical uses of white balance later in this chapter.

WHITE BALANCE AND COLOR TEMPERATURE

White balance is closely associated with color temperature, in that white balance is based on a color scale, measured in degrees Kelvin, which goes from amber to blue. Light temperature, however, is not the only variable affecting white balance; the camera also occasionally adds additional color correction, particularly to prevent color shifting along the magenta/green axis.

Color temperature is expressed as a number plus the letter K (for degrees Kelvin—the convention is not to use the degrees symbol, however). Color temperature is best understood if you compare two numbers: A lower Kelvin number is warmer than a higher number.

For example, 3200K is approximately the temperature of a household incandescent light bulb, while sunny daylight ranges from about 5000K to 6500K. If you set your camera's white balance to the daylight setting and take pictures in each of those lighting conditions, the household lighting would produce a much warmer (yellow or orange) appearance in the images than the daylight would. The daylight would appear more neutral in the photos

White balance can have a major effect on your final image. Your vision for the image might be a cool, blue feel (left), a neutral, realistic look (center), or a warm, orange glow (right). Understanding the white balance tool and knowing how to use it can help you achieve the look you want.

(i.e., whites are pure, without color casts, and skin tones look normal) because the setting on the camera will have matched the actual light temperature more closely. If you were to take a picture in a shaded area or under a very overcast sky, using that same regular daylight setting, the image would bear a bluish cast because the actual color temperature of shaded or overcast light is higher than that of sunny daylight—anywhere from 6500K to 10000K.

Auto white balance can accurately reproduce neutral colors in difficult lighting situations that might have multiple light sources, such as a warehouse with artificial light and skylights.

AUTO WHITE BALANCE (AWB)

Canon camera designers have worked to design the Auto white balance control (AWB) so that it renders colors more accurately and naturally than that of earlier D-SLRs. In addition, improved algorithms and the DIGIC 4 processor make AWB more stable as you shoot a scene from different angles and focal lengths (which has always been a challenge when using Auto white balance). It should be noted, however, that while vast improvements have been made, the only way to get truly consistent white balance from image to image is to take a Custom WB reading for each shot.

AWB has a color temperature range of approximately 3000-7000K. When set to AWB, the camera examines the scene, interprets the light in the range specified above using Canon's internal DIGIC processor, compares the conditions to what the engineers have determined works for such readings, and sets a white balance to make colors look neutral.

However, AWB is not always consistent. If you change focal lengths or move around in a scene (changing backgrounds for example), AWB can pick up slightly different wavelengths of light, shifting the white balance, even though the primary scene is still the same. It doesn't know that your change is not a lighting change, so it may readjust white balance. In addition, AWB will often give you a white balance setting that is a compromise between multiple types of light that it detects, and is not necessarily the best selection possible.

AWB can be a useful setting when you are moving quickly from one type of light to another, or whenever you want neutral colors and need to shoot fast. Even if it isn't the perfect setting for all conditions, it will often get you close enough so that only a little adjustment is needed later using your image-processing software.

When shooting outdoors in sunny conditions, use the Daylight white balance preset to accurately reproduce a natural light temperature.

WHITE BALANCE PRESETS

White balance presets are specifically defined white balance settings. They include the standard settings such as Daylight or Cloudy, as well as settings you define using Custom white balance.

Color is very important to me. When I was editor of *Outdoor Photographer* magazine, I spent a lot of time with the art director reviewing proofs from the printer. A slight color cast one way or another can really damage the look of any photo, especially a nature photo. In fact, Ansel Adams once said that he disliked color prints because he could never really get the color casts controlled the way he wanted.

One of the most consistent challenges I see digital photographers facing is white balance, because it affects color so much. I do not recommend shooting Auto white balance (AWB) except for specific needs as mentioned above. I do find, however, that most of the time, I can use the camera's preset WB.

One thing to keep in mind is that white balance is relative and has a lot to do with our perceptions and how we see the world. There is no such thing as a correct white balance, although you can certainly have some very wrong ones! White balance is an important tool for the digital photographer. It is worth spending some time with doing a few experiments so that you know how your camera responds to light at different settings and how you like the results.

DAYLIGHT WHITE BALANCE

Daylight white balance in Canon cameras is set to approximately 5200K (all numbers are approximate because of the way different models measure degrees Kelvin and because of the additional relationship of the setting to the magenta/green scale). This setting adjusts the camera to make colors appear natural when shooting in sunlit conditions between about 10:00 A.M. and 4:00 P.M. (middle of the day). At other times, when the sun is lower in the sky and has more red light, the scenes photographed using this setting will appear a little warmer than we tend to see them with our eyes (it is usually a pleasing look, though). It makes indoor scenes under incandescent lights look very warm (often too warm to make for a good-looking picture).

SHADE WHITE BALANCE

Shade white balance is set to approximately 7000K on your Canon camera. Shadowed subjects under blue skies can end up very bluish in tone, so this setting makes the light look more

neutral or even warms it up. The Shade setting is a good one to use anytime you want to warm up the appearance of a scene (especially when people are included), but you have to experiment to see how you like such a creative use of the setting.

CLOUDY WHITE BALANCE

Cloudy white balance is set to approximately 6000K. Even though the sym-

Shady areas on a sunny day have a cooler light temperature; the Shade preset warms up images shot in these conditions. The Shade setting can also be applied to images shot in sunny daylight to create a more distinct warming effect.

bol for this setting is a cloud, Canon gives its full name as the Cloudy/Twilight/Sunset setting. It makes cloudy scenes warmer, as if you had a warming filter on the lens. If Cloudy is set when the sun is out, the light becomes warmer, but not quite to the degree it does when Shade is set in similar circumstances. You may prefer the Cloudy setting to Shade when photographing people because the warming effect is not as strong. Both settings actually work well when taking sunrise and sunset photos, capturing the red and orange colors that we expect to see in such photographs.

The Cloudy white balance setting applies more warming to a scene than the Daylight setting, and less warming than the Shade setting. It produces neutral colors in cloudy conditions, and slightly warms subjects shot in daylight conditions.

TUNGSTEN LIGHT WHITE BALANCE

Tungsten Light white balance is set to approximately 3200K. It is designed to produce natural-looking results with quartz lights (which are generally balanced to 3200K). It is also a good setting to try when shooting indoors with incandescent lights. It reduces the orange cast that is typical when photographing lamp-lit indoor scenes with daylight balanced settings. Since this control adds a cold tone to scenes with higher light temperatures, it can also be used creatively for this purpose (to make a snow scene appear more blue, for example).

FLUORESCENT LIGHT WHITE BALANCE

The Fluorescent Light white balance preset is set to approximately 4000K, but the magenta/green adjustment will vary depending on the camera model and its specific settings. Canon cameras that are marketed to amateur photographers will typically have one Fluorescent setting, while most professional models have two or more. Frankly, AWB often works well with fluorescents, because fluorescent lights can be so variable. Or, due to this variability, you may even find that Custom white balance is best to achieve the most precise color.

But under many conditions, a specific Fluorescent preset can be effective and predictable. Fluorescent lights usually appear green in photographs, so this setting adds magenta to neutralize that effect. You can also use this setting creatively anytime you wish to add a pinkish tone to your photo (such as during sunrise or sunset).

The Fluorescent setting removes the green cast that commonly appears in images shot under fluorescent lights, as you can see in this example.

The Flash white balance preset is an excellent setting for photographers that frequently utilize on-camera or accessory flash. Flash is slightly cooler than daylight, so balancing it with the Flash white balance setting warms the look of the image and makes the subject appear more natural.

FLASH WHITE BALANCE

Flash white balance is set to approximately 6000K. Light from flash tends to be a little colder than daylight, so this warms it up. This setting is very similar to Cloudy (the Kelvin temperature is the same). I actually use the Flash preset a lot, finding it to be a good, all-around setting that gives a slight but attractive warm tone to outdoor scenes.

COLOR TEMPERATURE (KELVIN) WHITE BALANCE

By going to the Color Temperature white balance setting, you can base your white balance on a specific Kelvin temperature between 2500K and 10000K. This setting offers a wide range of

possibilities. I recommend it for photographers who are experienced in using a color-temperature meter and color-compensation (CC) filters, as well as for anyone interested in tweaking white balance values for more precise control than is possible with the presets.

CUSTOM WHITE BALANCE

Custom white balance is a very important tool for the digital photographer. It can be set to a range from approximately 2000-10000K, and it is a precise and adaptable way of getting accurate or creative white balance. It has no preset Kelvin temperature, but rather determines the appropriate temperature setting after measuring a specific neutral tone in the light to be photographed. It deals with a wider range than the Auto and Color Temperature WB functions, and that can be quite useful.

For most Canon cameras, you set Custom white balance by first taking a picture of something white (or something you know is a neutral tone) that is in the same light as your subject. You can use a piece of paper or a gray card. It does not have to be in focus (though your camera won't fire if it is set to One-Shot AF and cannot find focus), but it should fill the image area. Be sure the exposure is set to make this object gray to light gray in tone, and not dark (underexposed) or washed-out white (overexposed).

Then you will normally go to the Shooting menu, choose [Custom WB], and push the SET button. The last shot you took (the one for white balance) should be displayed in the LCD screen. Otherwise, scroll through your photos to choose the image you shot of the white or gray object. Push the SET button again and the white balance is adjusted to that shot.

NOTE: Many papers have ultraviolet brighteners in them, which will be read as blue by the camera. You may find you get a warmer than expected result if you use such papers as the target for Custom white balance.

Now you can use this measured Custom setting by choosing the Custom WB icon in the white balance menu. This new white balance setting will stay associated with the Custom choice until you repeat this process for a new subject.

The Custom white balance setting can be used with any subject in any lighting situation. It is highly consistent, however, it will only reproduce a neutral color temperature under the exact conditions it was programmed for.

You can also use Custom white balance to creatively color a scene. For example, you could target a color that is not white or gray. If you used a pale blue, the camera would adjust the color to neutral, which in essence removes blue. That scene will therefore

have an amber cast. You can use different strengths of blue (or other colors) for varied results. Sample color chips from a paint store work great for this.

The following illustration provides a visual explanation of color temperature, as well as a quick-reference guide if you're trying to decide how to set your Color Temperature white balance.

Candle Flame	1850
Sunrise or Sunset	2000
100-Watt Incandescent Lamp	2865
Professional Tungsten Photo Lamp	3200
One Hour After Sunrise	3500
Fluorescent Light	4000
Early Morning or Late Afternoon	4300
Summer Sunlight at Noon	5400
Electronic Flash	5500-7000
Direct Summer Sunlight	5800
Overcast Sky	6000
Summer Sunlight	6500
Summer Shade	7000-8000
Plain, Clear Blue Sky	10000

*Other factors in addition to temperature affect the color of Fluorescent light, and therefore its color doesn't fall on the color scale where you might expect it to. It's actually green, rather than yellow.

Many photographers use presets creatively to produce a certain effect in an image, such as setting the white balance to Cloudy or Shade to intensify the orange and yellow hues of a sunrise.

CREATIVE USE OF WHITE BALANCE

You have already read several references to using white balance settings that do not match to the conditions of the scene; for instance, taking a sunset photo while white balance is set to Shade. This is a good way to creatively control the colors within a photograph. While you can make creative adjustments to white balance later in Photoshop or other image-processing programs, it can be very effective—and reassuring—to control the color while you are taking the picture.

There are no fixed rules about this. A good way to learn how white balance can creatively change the appearance of the scene is to take multiple pictures of the same scene while you alter the white balance settings. I recommend that you do this for more than one scene, because changes to white balance can sometimes yield unexpected results in different scenes. The key is to get a feeling for how changing the white balance can warm a scene up or cool it down.

DOES RAW REPLACE THE NEED TO SET WB?

Since the RAW format allows you to easily change white balance after the fact using RAW processing software in the computer, some photographers believe that it is not important to select an appropriate white balance at the time the photo is taken. I cannot recommend that. The choice of white balance is important. When you open up RAW files in processing software, the files are displayed with the settings that you chose during initial image capture (this can vary depending on the software—Canon software will use the settings exactly, while Photoshop® Camera Raw, for example, uses an interpretation of the settings).

Sure, you can edit white balance settings in the computer, but why not make a good RAW image better by merely tweaking the white balance with minor revisions at the image-processing stage rather than fighting images in a workflow that does not define white balance from the start?

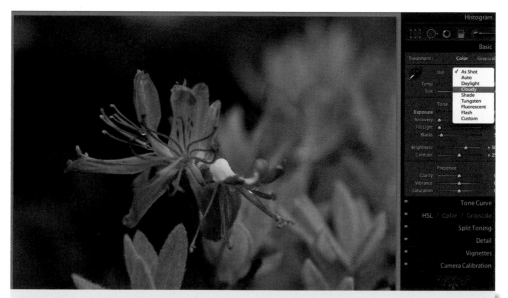

RAW files are more flexible in terms of post-processing—for example, you can change the white balance setting after the capture has been made—but it is wise to shoot the subject in the way that best matches your final vision at the time of capture and not depend on post-processing to create an image.

Experiment with the white balance settings available on your camera. Many compositions benefit from small choices—such as overall image hue—and can create an image that communicates a specific mood or atmosphere.

Natural Light

Light is a very important part of a photograph, yet when taking pictures, many photographers see the subject and not the light. They are overly influenced by what the subject is instead of how the subject is illuminated. Because we can see the subject well does not mean the camera can, too. Light has a huge effect on what that subject looks like.

Light can complement and support the subject. It can enhance, brighten, enrich, dramatize, and affect that subject's appearance in very positive ways. Light can also compete with the subject. It can distort, hide, and otherwise change a subject's appearance in ways that will not help your photo. It is much easier to see your subject in real life because you and the subject can change position in relation to one another, changing visual references. But, the human eye sees colors and dimensions differently from how the camera captures them. For these reasons, it is important to understand how light works if you want to produce images that convey your perception of them.

Natural light is a highly variable kind of light. Its intensity, color, and quality all change. By understanding the nuances of natural light, you will be better able to master it in all conditions.

TYPES OF NATURAL LIGHT

Because each type of natural light behaves differently from every other in terms of color temperature, intensity, contrast, and shadows, it is important to find ways to make each one work for you. The following section will help you better understand how each one works and how you can work around or manipulate each one to get great photos.

BRIGHT SUN ON A CLEAR DAY

When the sun is shining and the air is crisp and clear, you will find some of the most brilliant, clean light possible. It is also some of the most difficult to work with; bright sunlight, as a camera captures it, exhibits a great deal of contrast between the darkest

and brightest values. Typically, you will be able to see into the shadows much better than the camera can because the range of values that your eyes can see is much wider than the *dynamic range* of the camera's sensor. (Dynamic range is the range of dark and bright values that the camera can capture in a single exposure.)

Bright sunlight creates very sharp shadows, sometimes making the shadows themselves quite interesting subjects. But, as I've said, it can be extremely contrasty, resulting in some serious exposure challenges. Often, it isn't possible to expose for the sun properly and get any real detail in the shadows, or vice-versa. In this situation, you're forced to choose one or the other—usually the brightest value—and expose for it, forgetting about capturing any detail in the other areas.

The key to working in bright sunlight is generally to watch where those highlights and shadows are. You have to recognize that what you see and what the camera sees may be quite different (once you get accustomed to your camera, you'll start to have a sense of what it is capable of in terms of dynamic range). Be sure the important parts of your subject are in the highlights and that you expose for them. Exposing for the shadows can sometimes get you into trouble, causing washed-out, ugly bright spots in the photo where the sun hits. In bright sunlight, you usually just have to find the brightest areas and base your composition on them.

This light is also highly directional, meaning that highlights and shadows are very precisely placed on the subject. For this reason, you often cannot use a composition based solely on the subject and its surroundings (even if you can see it fine with your eyes). Making even a slight change in camera or subject position can dramatically affect relationships of light and dark areas, which means you need to select these positions very carefully. You have to find a composition that works with the light.

An important aspect of working with bright sun is to really look at shadows and highlights. Often, a good exposure for the highlights will mean dark shadows, but those can be interesting graphic elements in the photo.

So, if you can expose your intended subject just right, bright sunlight can make for interesting and dramatic images—partly due to the distinct shadows, and partly because it really features and highlights bold colors (subtle colors, on the other hand, can be obscured). The most important thing is that you must work with this type of light to make it work for you rather than against you.

OPEN SHADE

Open shade refers to any daylight that does not come directly from the sun: the shade of a building or a tree, an overcast day, or a window or skylight that doesn't have sunlight pouring directly into it, for example.

When you are in open shade, you will find that shadows are far less distinct, though exactly what shadows look like will depend on how large the open sky is that is creating that light. The larger the area of sky, the more indistinct the shadow edges will be. A smaller area of open sky illuminating your subject (i.e., it is blocked by buildings, trees, or other tall objects) will make for more prominent shadows. Regardless, contrast is generally reduced in this type of light.

Due to the relatively soft shadows, open shade is very flattering light for photographing people, plus they won't be squinting because of the sunlight. It actually works quite well with any subject that has subtle tones and colors that would be obscured by strong light and shadow effects.

Open shade is a soft and open light. Because it comes from the sky, it can be very blue if you don't set your white balance correctly. To get the white paint and the skin tones in this photo to look natural, I set my camera's white balance to the preset Shade setting.

Besides the spreading out of light, a very important characteristic of this light is its color. When there are few or no clouds in the sky, this light becomes very blue. We don't see that blue the way a camera does. This makes the white balance setting of a digital camera very important. Auto white balance often misses the best color in these conditions. Use Shade or Cloudy presets to warm up the subject and remove the blue.

HAZY SUN

Add some light clouds in the sky and the sun gets pretty hazy, which totally changes how it affects a scene. The sunlight is diffused, plus the clouds themselves reflect light from other parts of the sky into and around the scene. This light can vary from a slight haze (such as a hazy summer day that just barely spreads

Hazy sun gives some definition to details in a scene, and really brought out the color in this image, but it is not as harsh or contrasty as bright sun on a clear day.

the light from the sun) to clouds that almost obscure the sun (you can still see it, but now the light is really diffused and spread out around it).

A hazy sun totally changes the relationship between highlights and shadows. There is still a distinct shadow, but it is softer than in direct sunlight. The more diffused the light is, the softer the shadow edges become. Plus, the contrast between highlights and shadows is reduced, softening the overall look of the photo. The dramatic shadows you get from bright sunlight are all but absent in hazy sunlight; it has a much gentler effect on your subject.

Colors will appear different too: Less haze (i.e., bright sunlight) emphasizes bold colors, whereas more haze will tone down bold colors and bring out the more subtle colors. So, bright sunlight is great lighting for a dramatic cityscape photo, while a hazy day might be a good time to take Easter portraits of the family, for example.

CLOUDY BRIGHT LIGHT

When clouds fill the sky and totally obscure the sun's position, yet it is still bright and light outside, you have cloudy bright conditions. This is a very diffuse and spread-out light. The light source becomes, in a sense, the entire sky itself, resulting in a more or less directionless light.

Cloudy bright light can be very flattering for photographing people, though it can lack dimension and, if it isn't dealt with properly, it can cause an unpleasant color cast in your pictures. This light can be a bit bluish and unattractive for some subjects, especially if you use AWB. Use the Cloudy or Shade white balance presets on your digital camera to render neutral colors and skin tones more accurately.

Shadows pretty much disappear except on the underside of subjects or in areas that are blocked from the sky. Even the few shadows that do appear have such soft edges that it is hard to see where the shadow begins and the highlight ends. It is more

Cloudy bright light is a soft and enveloping light that can even penetrate a forest. It can make for great color saturation, as long as you set your white balance appropriately. Canon cameras feature a Cloudy white balance preset.

a gentle rounding of tonalities from light to dark—i.e., even less contrast than hazy sunlight. You can often photograph colors and tones of a subject more accurately because what the camera sees is closer to what you see with your eyes.

This can be a challenging light for digital cameras. Because it is generally soft and low in contrast, it frequently does not use the full capabilities of a sensor. No matter how you expose the subject, you will find it difficult to get a pure black or pure white, which can cause digital images to exhibit less snap and color. To compensate for this, you can adjust the shooting parameters (known as Picture Styles) on your Canon camera to increase the contrast and saturation that it captures. These settings affect JPEG photos and give instructions for RAW photos processed in Canon's RAW software; they are found in the Shooting menu on Canon cameras

(they can also be accessed directly on some models via a Picture Styles button on the back of the camera).

When handled properly, cloudy bright can be a very enveloping, soft light that will feature gentle contours and colors. It is not a light for drama and high energy. It will actually tone down scenes that have those characteristics. Watch what happens when a cloud obscures the sun on an otherwise bright sunny day—take a picture and compare it to the ones you took before the cloud came along, and you should be able to get an idea of how this type of light will affect your photos with your particular camera.

HEAVY OVERCAST

As clouds collect and intensify, light levels drop and cloudy bright goes to cloudy dark. This can be a difficult light to use—but it can be very rewarding, too. It can look heavy and gloomy, plus with less available light, exposures require higher ISO settings, slow shutter speeds, and/or wider lens openings. However, it can also allow light to penetrate deeply into a scene in a much more

When it rains, many photographers quit shooting, yet even during these heavy overcast conditions, the light can be quite interesting for the right subject. It can really even out the light in a normally contrasty scene.

balanced way than in any other condition, potentially resulting in especially saturated colors in your pictures.

Many pros avoid this light altogether because its dark, heavy appearance is unflattering to most subjects (except when you want to show off a storm and its light, of course). The light has

This scene was shot during a break in a snowstorm. Such conditions give a very open feeling to the landscape because the snow brings out a lot of details throughout the scene.

very little dimension or form to it because there are no shadows to speak of.

When you are photographing in these conditions, avoid Auto white balance. You especially need to add some warmth to the photo as the camera will tend to see cooler and grayer tones than your eyes do. Add that warmth with Cloudy or Shade white balance. Or try a pro's trick of using Custom white balance and white balancing on a pale blue card (a blue paint sample card from the paint store works great)—the camera removes that blue and warms up the scene.

Also, for certain subjects, try turning on your flash. The flash will often brighten up an overcast scene, bringing out colors that just don't register well otherwise. Even a built-in flash in a Canon

point-and-shoot digital camera will often help. With Canon's D-SLRs, you can even try adding more or less light from the flash (by adjusting the flash compensation) for more creative control. Try using slow sync flash if you want to get a good exposure of your foreground subject without totally obscuring the background. On most Canon D-SLRs, you can set the camera for Night Portrait, and it will automatically do this for you. On most Canon non-SLRs, you can set the camera for slow sync (or synchro) flash.

Rain and snow can add an interesting element to a cloudy day scene. This is the time many photographers put their cameras away, yet precipitation can bring some special qualities to the photograph that will enliven a scene. Rain can add some sparkle and dimension to otherwise dead space in the frame. Puddles can make for interesting subjects or backgrounds because they often reflect colors or even entire scenes. And, falling snow gives an almost ethereal look to an image. (See pages 262-267 for tips on how to protect your camera when shooting in elements like rain and snow.)

TIME OF DAY

The time of day that you take pictures changes the look of light and how it affects the subject. Light changes throughout the day, and can create very different looks on the same subject. In fact, an excellent exercise for photographers is to try photographing the same subject throughout a sunny day, from sunrise to sunset, and even before and after the sun is in the sky. The time of day affects several important elements of light, including:

Late sun can give a very appealing, warm light to a subject. You do have to set a higher temperature white balance, however, such as Cloudy.

Early morning sunlight is a crisp yellowish light that is quite dramatic. This is not an open light that shows off everything, but a theatrical light that spotlights details, like the angles and textures of this building.

◆ **Color:** Sunlight early in the morning tends to be yellowish (though it can be orange or, more rarely, red), while shadow light is generally very blue. As the sun rises higher in the sky, it appears more neutral to the eye and the camera. By mid-day, the light can start to look a little bluish because of the way it interacts with the air and the sky. It gets more neutral by mid-afternoon, then warms up as the sun gets close to the horizon. Late sun tends to be orange or red (much warmer than morning light), though it can also be simply yellowish.

◆ **Direction and dimension:** Light is far more directional early and late in the day than in the middle of the day. This is one reason why most landscape and travel photographers take the majority of their photos during those times. It just gives them more options to capture light that works with the subject.

◆ **Crispness:** Light tends to be at its crispest and sharpest first thing in the morning. During the day, dust, water, pollution, and other things get into the air, diffusing it, spreading it out, so light at the end of a day is often quite a bit softer than in the morning. In areas along coasts where there is a lot of fog, of course, this might not apply, as fog is most prevalent in the morning.

SUNRISE AND SUNSET

Sunrise and sunset are the times of day when you can get some very dramatic light, bold in its direction and its color. While beginning photographers are very much attracted to the actual sun in

Sunrise and sunset offer great opportunities for colorful, dramatic photos. Be sure to choose a specific white balance setting instead of Auto white balance if you really want the best color. This was shot with a telephoto focal length, in order to both magnify the mountains and visually compress the mountains and the sky together.

the sunrise and sunset, there is much more to the light and the conditions than simply the sun rising or setting.

This is a time for some very rich light on your subject. It is also time to be sure you are not using Auto white balance. Auto white balance will remove some of the richness of the color in its efforts to make this scene more neutral. Choose Daylight, Cloudy, or Shade settings. For an interesting (and non-standard) effect, you can try fluorescent or tungsten settings.

Look in directions other than toward the light. Sometimes the low, warm sun will give amazing results when you turn away from it, but beware of catching your own shadow in the photograph when the sun is behind you.

TWILIGHT

A lot of photographers put their cameras away when the sun sets. Yet there are some amazing opportunities for great photos after the sun sets—both of the changing sky, and of the light on darkening scenes. Canon's D-SLRs will continue to record color and detail from a scene even as it gets dark. You may be surprised at the amount of color the camera sees when it's dark enough that your own eyes can't.

It is hard to predict whether you will have good conditions for twilight or not. Sometimes you'll wait and nothing will happen. Most the time you will find the light will actually get worse for the first few minutes after sunset, but after another five minutes or so, typically, the light will improve.

Obviously, you will need a tripod, as exposures will be long. When the sun first sets, you may have exposures that are a few seconds long, but as the light disappears, this can stretch into minutes. Be sure your camera's noise reduction for long exposures is on.

Long exposure noise reduction will help to reduce the noise caused by the heat that the sensor generates during long

Light after the sun has set will often get more interesting as you wait for darkness to fall. This photo was shot 20 minutes after sunset, capturing this colorful light.

exposures. To turn on long exposure noise reduction, find it in your SLR's Custom Functions menu and set it to [On]. Some non-SLR cameras offer noise reduction too, but it is likely to be applied automatically when you take a long exposure or set a high ISO. The in-camera processing associated with noise reduction will slow things down a bit; you will probably have to wait as long for the noise reduction to work as the actual time for the picture. Try to avoid high ISO settings when you take long exposures, as this will increase the noise even more.

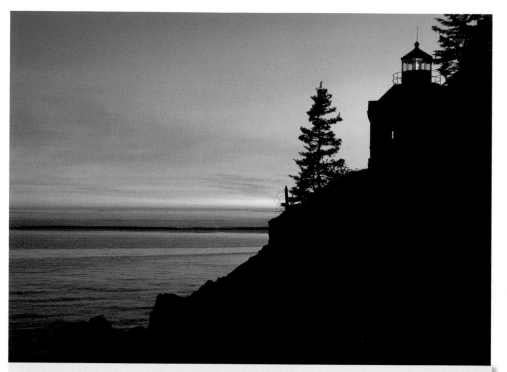

Twilight often provides wonderful sky color. Shadows will be quite dark, though, so use them carefully in your composition.

OUTDOORS AT NIGHT

A Canon digital camera, with its variable ISO and white balance settings, plus LCD review, makes night photography not only possible, but fun and productive for any photographer. Here are some suggestions to help you get great photos of your subjects after dark. (For more on shooting in low light, see pages 161-168.)

Night cityscapes: Although cityscapes usually feature more artificial light than natural light when they are the subjects of photographs, we deal with them as if they were naturally illuminated. You cannot supplement skyline light with your flash, because the subject is too big and too far away. Furthermore, it is impossible to compensate for shifts due to light temperature, because cityscapes feature such a huge variety of light types. So, in many ways, you must simply capture them as they are.

That said, when the sun goes down and lights go on in the city, there are some amazing possibilities. You may find that a little daytime scouting will pay off quite nicely, and if you're not familiar with the city, you can check with people who live there for their recommendations—maybe stop into a camera store and ask them where they like to shoot. Sometimes you can find a neat angle from a postcard and ask if anyone knows where it was taken from.

Be sure to bring along a tripod and a telephoto lens, although you may want to experiment with other lenses too. Start shooting cityscapes as the sun sets. There is a very magic time that occurs as the sky still has color and the city lights appear, which

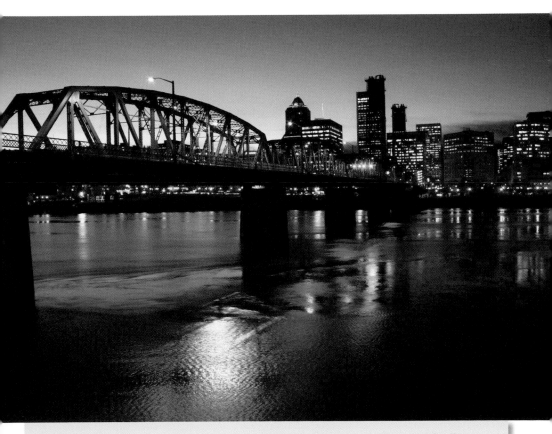

Twilight makes for the most beautiful cityscape photos. I recommend finding a good vantage point, beginning to shoot right before sunset, and shooting into the night. You'll be amazed at how much the scene changes as the light changes.

is usually a little after sunset. You can never predict when the perfect time will be, though, so be patient.

Cloudy days can be dull for a city during the day, but perfect at night. The clouds reflect back some of the city's light, giving some tonality in the sky to show off the shapes of the buildings. Try different white balance settings, though Daylight usually works best because it will often give a nice warm look to the city.

Lightning: Lightning can make for stunning photos, but it can be challenging to capture. First thing, be sure you are in a safe location that will not be a target for the lightning—never set up under a tree, for example. Set up your camera on a tripod and point it toward the lightning. Try setting the aperture and ISO to f/5.6 and 100, white balance for Daylight and the shutter at B, or Bulb (lightning is very hard to predict, so try some shots and modify the settings accordingly). Open the shutter and wait for lightning—you can even leave it open for several lightning strikes. This only works at night, though, because leaving the shutter open during the day will overexpose the image.

If you get really serious about lightning photography, you might look into a product called the Lightning Trigger. This attaches to cameras with remote or electronic cable releases and triggers the camera when it senses a lightning strike. This way, you don't need to leave the shutter open, and can even shoot during the day.

Moonscapes: A full moon is a very bright light and can illuminate a landscape. Exposure can be tricky and you may have to experiment a bit. Working with large reflective surfaces, such as big expanses of rock, water, or snow, can be especially effective, but forests usually don't look that great in moonlight. Try both Daylight and Tungsten white balance. You may find you need moderately high ISO settings in order to get shutter speeds of 15-30 seconds at fast to moderate f/stops.

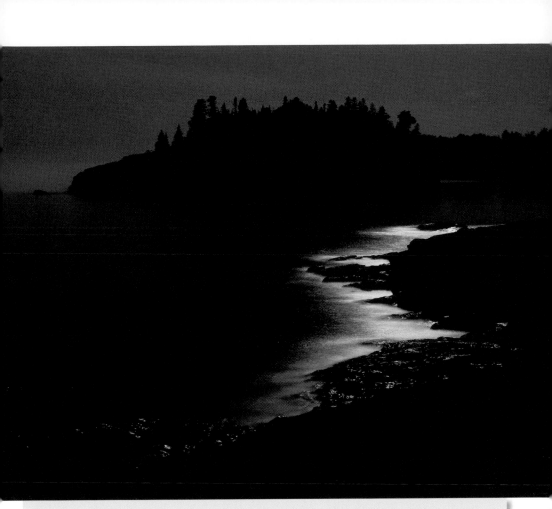

A coastal scene like this one is a great moonscape subject. There are no city lights to obscure the moonlight, the water reflects the light beautifully, and the shore creates a dramatic line that draws the viewer's eye into the image.

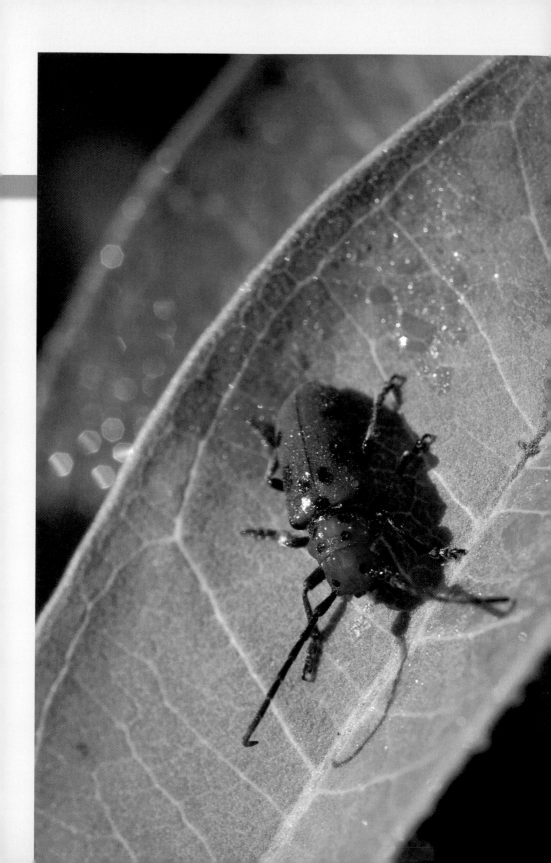

Artificial Light

Digital photography has opened up new possibilities for great images in almost any kind of light. Color film captures the color of light in very restricted ways compared to how our eyes see it. It enhances and exaggerates the colors so that if the film is not balanced for a particular light, the colors look bad, such as sickly greens under fluorescent light or orange casts under incandescents. You can use a specific film balanced for certain lights, and you can use filters, but overall, getting good images from non-daylight conditions is challenging with color film.

Digital cameras, on the other hand, allow you to easily change how the camera reacts to different types of light. This setting is known as *white balance* (for more on white balance, see Chapter 4). For example, if you are shooting under incandescent light and your camera's white balance is set to incandescent, the colors should be captured more accurately—as opposed to appearing orange or yellow—than they would with daylight-balanced film or a Daylight white balance setting.

Understanding how the various types of artificial light look in photographs will allow you to, among other things, show their effects in your photos and use the light as part of your subject, like I did with this scene.

Artificial light can come from any man-made light source that brightens a scene, from a candle to an off-camera flash, and it may be the primary light source for the image, or just part of the total light illuminating the scene. Each type of artificial light gives off a specific color (or range of colors) of light, and the following section will help you learn how to work with them and use them to the advantage of your images.

TYPES OF EXISTING ARTIFICIAL LIGHT

Like the various kinds of natural light, every type of artificial light bears its own set of characteristics. And of course, understanding how each one affects your images will give you a great deal of control over the final product—not to mention allow you to spend less (or no) time in front of a computer editing your photos.

TUNGSTEN LIGHT

Tungsten, or incandescent, light is the common artificial light in homes, public halls, and other indoor settings. It can vary considerably, depending on the type of fixture it comes from, as well as the size of the bulb.

Typically, incandescent light is pretty contrasty, because it usually comes from a small source (a bulb). This will result in hard-edged, sometimes unattractive shadows, but you can also use this edge for a creative effect. If the light is bounced off of a wall or ceiling, or is in a fixture with a large, diffuse shade on it, the light will have a softer effect, sometimes even to the degree of shadows becoming indistinct (see pages 150-152 and 177-179 for more on bouncing and other ways to modify light).

Incandescent, or tungsten, light can really create a mood for a photo. It gives a warm, calm feel to this otherwise busy scene.

This light has a low color temperature (on the Kelvin scale), usually 3200K or less. This means that with most white balance settings it will be a very warm-looking light. You can usually get a fairly neutral look to the colors by shooting with Tungsten white balance. No matter what white balance setting you use, however, these conditions often prevent a camera from getting purely accurate colors.

Often, an indoor setting will look more appealing with a warmer tone, so you may actually want to set something with a higher temperature, like Daylight. You can also use a Custom white balance setting or a specific Kelvin temperature white balance. A Kelvin white balance above 3200K will make the picture look warmer, while a lower setting will make it look cooler.

FLUORESCENT LIGHT

Fluorescent light is a rather tricky light to work with. Fluorescent lights are extremely variable; there are a number of kinds of fluorescent lights on the market, each with a different color. They are also known to change in color as they age. A Canon D-SLR is perfectly capable of handling this challenge, but you will have to do some work with the white balance settings.

Your Canon camera will give you at least one Fluorescent white balance setting, although many offer more. You may literally have to try each available choice in a given scene to be sure you get the best color. If you are really having trouble with color in a fluorescent light situation, then your best bet is to use a specific Kelvin temperature setting or Custom white balance. Another helpful feature is that most Canon D-SLRs have white balance bracketing. This will allow you to take one picture, but the camera records multiple images (usually three) with different white balance settings.

Fluorescent light can be incredibly unflattering for skin tones, eye color, and facial features, so I used my camera's Fluorescent white balance preset to give this image a warmer look.

One challenge with fluorescent light is that it often is an unattractive top-light. This can create real problems for photographing people by making their eyes very dark, among other things. One way around this is to use a reflector below their faces—even if the reflector is on the ground, it'll do the trick. Another way around it is to use a flash to illuminate those eyes, but straight flash will be the wrong color—it won't balance with the color of the fluorescent light, and the two different colors of light will be apparent in the image. You would need to add a green filter to the flash to at least come close to the color of a fluorescent light (you can buy such filters at a camera store). Since this flash is just used for fill light, however, the filter doesn't have to be perfect in color. Set your Canon camera to Av mode and the flash intensity will be automatically balanced to that of the existing light.

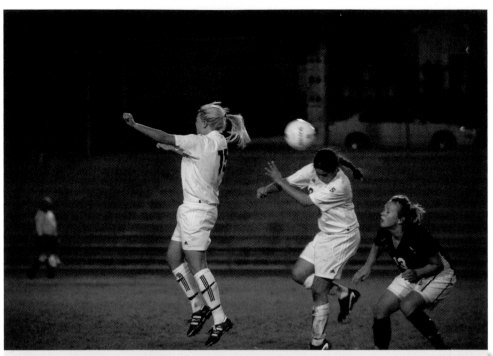

Most cameras do not offer a white balance preset for stadium lights, but they're not too far from daylight in color temperature. You could take a custom reading, but AWB or the Daylight preset might work just fine for you.

STADIUM LIGHTS

Sooner or later, if you are doing much sports photography, you will end up shooting under stadium lights. These lights are typically mercury-vapor, though not always. Usually, you can get reasonably good color under mercury-vapor lighting, although you can't expect color like you would see during the day.

These lights tend to be close to daylight in color temperature, but not in the total spectrum of daylight. The spectrum of light, along with its temperature, affects how color appears. I have found I get the best results with these lights either by shooting with Auto white balance or by setting a Custom white balance.

These lights tend to be high above the field, very directional, and with a lot of contrast. However, the lights typically surround the

entire area, which will help to fill in some shadows, but it will also create a lot of them. Watch where they fall so that you don't end up with awkward shadows on or around your subject.

QUARTZ LIGHTS

Quartz lights are a standard type of studio lighting, although you don't need a studio to use them. They do require access to electrical power. These lights are often called "hot lights" because they get very hot while they are on. They are continuous light sources, as compared to the other common type of studio light, the electronic flash, or strobe, which syncs to your camera and flashes only when you take the picture.

The big advantage of using quartz lights is that you see exactly what you are going to get as you set them up. Put them on stands and move them around wherever you would like, and you will see every change you make in terms of light position. Another advantage of quartz lighting is that you can simply change your shutter speed to get more or less exposure, and you don't have to worry about changing the intensity of the light source. Their major disadvantage is heat.

When shooting with film, we used to have some challenges with quartz lights because of their color temperature of 3200K. This is a color temperature considerably different from common films, which are daylight balanced, so you either have to use a filter on the lens to compensate or you have to use a tungsten film. Neither of those is very convenient and can create real workflow problems.

With a digital camera, however, you can change your white balance at any time to match any light. You can use a Tungsten white balance, or even a specific Kelvin temperature of 3200K. This will give you excellent color with quartz lights. Because they are relatively inexpensive, easy-to-use, and you can set your camera to

match their color temperature, quartz lights have become a very popular way of setting up indoor lighting when shooting with digital cameras.

ELECTRONIC FLASH

An entirely different type of artificial light, meant to simulate daylight, electronic flash is commonly used both indoors and out-doors. Flash is not a continuous light source; it provides a quick burst of light when you take a picture. Because of that, it can be difficult to see exactly what a flash is doing when it goes off.

Flash does, however, offer several advantages. These lights do not get hot the way quartz lights do; and in the case of Canon flash units, power is self-contained (in the form of AA alkaline, lithium, or NiMH batteries), which makes them very por-table. And, because their color temperature match-es daylight, they're great for shooting outdoors.

Digital cameras with their LCDs definitely help you to see how to best use flash. Canon also provides another interesting way of seeing the effects from a flash. Press the Depth-of-Field Preview button on a D-SLR, and an attached Canon accessory flash will provide a burst of light

The Speedlite 430 EX II is one of several ac-cessory flash units available from Canon that will give you a much better range and more features than the on-board units.

so you can see where it is hitting your subject. This useful feature has two limitations: Unfortunately, it does not work with the built-in flash; and you have to be sure you have plenty of battery power, because it will use up your batteries very quickly.

Canon flash is really a complete system that includes both the flash and the camera. Canon offers a varied selection of flash units for different purposes, which are tightly connected to camera operation. Through the built-in E-TTL flash exposure system in the camera, exposure is calculated every time the flash fires. It works like this: The flash puts out a burst of light, called a pre-flash, before the actual exposure. This light goes out into your scene, and then bounces back to the camera through the lens. The camera then uses its advanced computing power to measure the light at several locations across the composition, adds in the distance to the subject based on the focus point of the lens, and creates an accurate exposure. All of this is done in literally a fraction of a second before the second flash (for the actual exposure) goes off.

When putting together your Canon flash kit, consider the following factors: First, the larger, more powerful flash units offer more in terms of both features and versatility. Second, having two or more flash units will give you a lot of flexibility in the type of lighting you can control. The larger Canon flash units also have wireless capability, meaning that they can communicate with each other for accurate exposures with multiple flash units going off at the same time; and they do not need to be hard-wired to the camera or each other to do this.

BUILT-IN VS. ACCESSORY FLASH

Most Canon pro model D-SLRs do not feature a built-in flash, so if you have one of these cameras, you'll have to have a separate flash unit. But, if you own one of their more consumer-oriented, lower-priced D-SLRs, you're faced with the following dilemma: Do you need to spend all that money on an accessory flash, or is the one that comes on the camera enough?

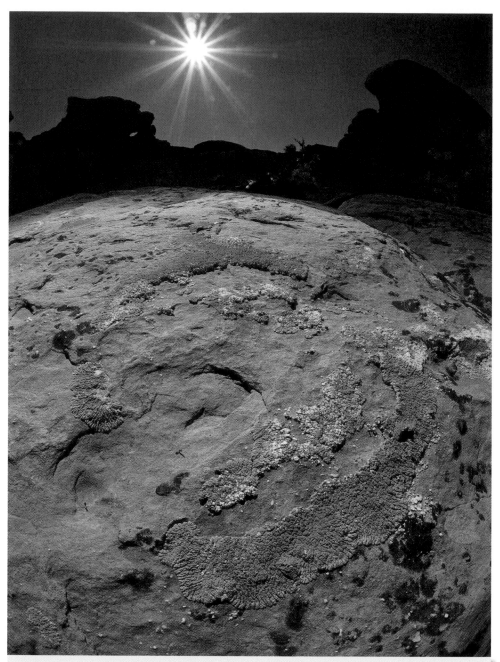

Flash isn't just for low light! I used a flash exposure for this shot to overpower the daylight and bring out the detail of the lichens in the foreground.

ISO	200	400	800
Flash Model 580EX II	49.2/15	68.9/21	98.4/30
430EX II	39.9/12.2	55.9/17	79.8/24.3
270EX	31.7/9.7	44.3/13.5	63.4/19.3
Built-in flash	4.6/1.4	6.6/2	9.2/2.8

The chart above is designed to give you an idea of how some of Canon's more popular accessory flash units compare with one another and with the camera's built-in flash. The actual range of a flash is affected by a number of common factors, including focal length, the angle of the flash head, and the presence or absence of environmental factors like dust, haze, and condensation. The numbers in this chart represent the absolute maximum possible distance each flash can cover given ideal environmental factors, a flash head pointed directly at the subject, a 50mm focal length, and an aperture of f/4 at each of the ISOs listed. This chart is meant to be used as a rough guide to help you understand what the limitations of your particular flash unit are and/or to illustrate how each flash unit is different in terms of the distance (in feet/ meters) each can cover.

FLASH OUTDOORS

Getting the right exposure by mixing flash and sunlight used to be difficult with older cameras and film, but with Canon digital cam- eras today, you will find that it is really quite easy to do. Flash can be used in two ways outdoors: First, it can be used as a fill flash, to fill in shadows so that they balance with the brighter areas of a photograph; and second, it can be used as a main light source, overpowering the existing daylight. It is possible to do both things with a built-in flash or an accessory flash, although you'll need a powerful accessory flash to completely overpower existing daylight conditions.

The easiest way to use flash outdoors is to set your camera to Aperture-priority (Av), and then turn the flash on (i.e., as a fill flash). Regardless of the type of camera, or whether the flash is a built-in or an accessory flash, this setting on Canon cameras will balance the intensity of the flash with the outdoor light to give you an accurate exposure. Choose an f/stop that gives you a shutter speed equal to or slower than the standard sync speed of your camera (standard sync speed will typically be in the range of 1/125 – 1/250). You must be at the sync speed of the flash or slower for the flash to have its effect.

Anywhere shadows can dull color, a little fill flash can bring it back to life!

What happens is that the camera automatically gives a correct exposure for the daylight conditions using both f/stop and shutter speed, and then it controls the amount of light coming from the flash to balance those conditions. This is a typical way of using flash to fill in dark shadows. If you find that the flash is a little bit

too bright, then dial it down with minus flash exposure compensation (see pages 173-175 for more on setting flash exposure compensation).

To use your flash as a main light that overpowers the daylight conditions, use your manual exposure settings to underexpose the daylight (remember to keep your shutter speed at the sync speed or slower), then just use your flash normally. The camera will control the flash to give a correct exposure for the flash based on the f/stop that you have used, basically compensating for the underexposure.

For a more subtle, softer effect, you can modify the light from the flash (and the daylight) using reflectors and/or diffusers. (For more on those methods, see pages 177-179.)

INDOOR FLASH PHOTOGRAPHY

You can use flash a variety of ways indoors: as the primary light source, as a supplement (or fill) to another source of artificial light, or as a supplement to daylight coming in through a window or a skylight.

The color temperature of flash more or less matches that of daylight, so if you're using it indoors to fill in shadows created by ambient daylight, or as the primary light source, you don't need to do anything special with your white balance settings. Setting white balance to either Auto or Flash should do the trick.

If you want to fill in shadows created by an artificial light source, however, it is slightly more complex. In this case, you are technically dealing with mixed light. If the color of the artificial light isn't too different from that of the flash, or if you're using the flash at a very low intensity, the color difference may barely be noticeable. If you find that the mixed light is obvious and adversely affects the quality of your images, you have a few options. You might find that using a filter in front of the flash is the easiest way to get it

to match the ambient light: an orange filter for incandescent light, green for fluorescent, etc. Or Custom white balance may be the answer (see pages 110-112). The simplest method for any indoor photography, however, is to use light sources that are all of approximately the same light temperature.

Another very important issue when using flash indoors, especially when it is the primary source, is shadows. If you are using only one on-camera flash, you might find that it casts a rather unpleasant-looking shadow on or near your subject. The simplest way to deal with this problem is to bounce the light from the flash so that it fills the room, illuminating your subject from all around, rather than from one direction.

BOUNCE LIGHT

You can bounce any light source, but it is most commonly done with flash. Bounce light is probably the easiest technique to get better photos of your subjects, especially people. You can aim any light

Take a picture under fluorescent lights without any correction at all (i.e., Daylight WB), and you'll get something like this.

Now, try it with flash (and Flash WB). The neutral (more or less daylight-colored) light from the flash almost overpowers the fluorescent light, but you can still see it in the shadows, where the light from the flash couldn't reach.

Put a green filter on your flash and do it again, this time setting your WB to Fluorescent. The color of both light sources is about the same, and compensated for by your camera's WB.

A green filter on your flash unit will balance the color of light from your flash with existing fluorescent light.

or flash upward or sideways so it is directed at a white ceiling or wall (or even a reflector). The light bounces off the surface, spreads out, and becomes more diffuse. The larger Canon flash units include a bounce feature that allows you to tilt the flash head up and rotate it.

Bounce light can be directional, such as a nice 3/4 or side light reflected from a surface very close to the light source, or it can be totally diffuse, like cloudy daylight. The wider the beam of light is (i.e., the farther away the source is) when it strikes the bounce surface, the more diffuse the bounced light will be. This means that if you bounce light off of a high ceiling, it will be less directional—fill the space more—than it would be if you bounced from a wall, say, two feet away from the light source.

Challenges come from the amount of light that is absorbed by the bounce surface. Some surfaces absorb more light than others, such as a dark wall or a rough ceiling. Plus, as the light is farther from the surface (like if the ceiling is especially high), and the light is spread out more, it uses up more power going the distance.

If you find you're losing too much light in this situation, use a tall light stand to put the source closer to the ceiling. If the light level still drops too much due to bouncing, increase the ISO setting on your camera. If you like bounce flash (as do most photographers who use flash a lot), you will need to get one of the larger accessory flash units. These have more power and will give you more options and control over bounce flash exposures.

Color can be another problem with bounce light. You need to be careful of the color of the surface where the bounce is coming from. Even a faintly colored wall, for example, can change the color of the light enough to make the color balance of the photo look bad. So, bounce your light off of neutral colored surfaces unless you are trying for a certain effect. (For more on modifying light, see pages 177-179.)

OFF-CAMERA FLASH

When a flash is mounted directly onto the camera, the source of the light is limited to one position. This can be a problem for the photographer, because a light that is close to the camera is not a particularly attractive light for many subjects. When you take the flash off the camera, you can move it around for optimum light on the subject. An off-camera flash will give you the opportunity get great shadows on and around your subject, plus you have more options for controlling the light from that flash, such as bouncing or diffusing the light.

The easiest way to use a single flash off-camera is to use a dedicated flash cord. This will allow you to move the flash up to 2 or 3 feet away from the lens of the camera, and the connection to the flash is secure and always functional, unlike with wireless flash. Off-camera flash can create much better light on a subject because you have some control over where it is coming from, yet the flash is still controlled by the camera. There is one other major advantage to putting some distance between the lens and

the flash: red-eye reduction. The greater the angular separation between the two, the less likely it is that your subjects will have red eyes in the photos, a problem that flash often causes.

Canon also has a special infrared remote trigger that can be put into the flash shoe to control certain compatible flash units without any wired connection. Furthermore, in recent years, Canon has developed a wireless flash system. This allows you to set up multiple flash units that are all controlled by a master flash connected to the camera, yet none of the other flash units are directly connected to that camera. They are all controlled (exposure and lighting ratios, as well as sync) by light coming from the master flash. This works extremely well indoors when the lights are all in one room. They have to have line of sight with one another in order to see the special light that is used to trigger them. For that reason, wireless flash doesn't always work outdoors or when a flash is behind something in the scene.

Off-camera flash can provide a more flattering, less direct light and prevent red eye. Most camera stores sell brackets on which you can mount the flash off and above the camera.

Just one basic light of almost any type can be used to illuminate a subject sufficiently and create dramatic shadows (if placed properly), as shown here.

BASIC STUDIO LIGHTING

The remainder of this chapter is dedicated to helping you understand how to use indoor lighting, as opposed to simply dealing with its presence. Most of the ideas, tips, and methods set forth here are applicable to a variety of light types, including but not limited to Canon wireless flash, studio strobes, hot lights, and ambient light.

USING ONE LIGHT

When beginning to work with lights, start out with one. With one light, you can see its effect exactly, without it being mixed in with other lights. You can use one flash or strobe, one quartz light, one fluorescent light fixture—any of these will work as a single light source. You will want to be sure that it is the *only* light

source in the room, because dealing with mixed light can get pretty complicated; so turn off all lamps and overhead lights.

Start with the light above and to one side of the camera. This is a good starting position, but not the only place that you can use a single light. The light from this position will give some nice three-dimensional light and shadows on the subject.

Next, see what the light looks like when you move it higher, then lower. Try moving the light toward the side of your subject. As you move the light to the side, you may discover that you really need a reflector to keep the shadows from getting too harsh (see pages 177-179). But this is a subjective decision, and you can get some very interesting effects with those dramatic shadows. Digital photography is really great for doing this sort of work because you can take the picture and immediately see what it looks like in your LCD.

You can also try moving your light behind the subject. Even experienced photographers are often reluctant to move a single light behind the subject, but backlight can make for bold and artistic-looking images. If your subject is at all translucent, this can really make it glow.

USING MULTIPLE LIGHTS

Working with multiple lights can increase your options for creating good lighting for a subject. You can use multiple quartz lights, wireless flash units, or any other grouping of more than one light source, but keep in mind that it becomes complicated if they are not all the same type of light (i.e., if they have different light temperatures). And, if you're not careful, multiple lights can create confusing lighting on a subject, so make any changes to their positions slowly and methodically, checking the effects in your LCD as you go.

The best way to work with multiple lights is to build a group of lights one at a time. You will look at the direction and quality of each light as it affects the subject. The direction is pretty straight-forward: front light (light hitting the front of the subject), sidelight, backlight, and top light. Each direction will change the way that shadows, colors, and textures appear in a photograph.

The quality of the light is affected by, among other factors, the size of its source. This does not necessarily refer to the physical size of the lighting fixture or flash unit itself, however, because the size of the light source is affected by how it is modified. A large diffuser or reflector modifying a small light will increase the size of the light and reduce the shadows on the subject (see pages 177-179 for more information). As the size of the light increases, the edges of the shadows will begin to blend, softer colors be-come more noticeable, and the direction of the light is less critical (though still important).

Two lights: Your first light is the main light, and it can be any-where around your subject. What you are looking for is a light that is going to define your subject and create some depth in the photograph.

One excellent position for a second light is directly opposite the first light. For example, if your first light is high and to the right of the camera, therefore lighting up the front and the left side of your subject, you can place a second light behind the subject and to the left of the camera, which will create a backlight from the right side of the subject. Another example would be if your first light were behind the subject, then your second light could be in front of the subject to fill in the shadows. One advantage of having a second light directly opposite the front light, is that you don't get confusing cross-shadows on the subject.

The second light should be a light that does something different and supports the first light. For example, you could have a dif-fused light hitting the front of your subject, while the second light is a hard-edged light that creates some rimlight (sort of a "halo"

Two lights, as seen here, can provide a little more dimension and even add sparkle to details such as hair.

look) behind the subject. A mistake many photographers make when adding lights is to simply add another light just like the first one but in a different position.

Another interesting thing to do with a second light is to shine it on something totally different in the photograph. You could light up the background, for example, to separate your subject from it, or to simply illuminate something back there that you want the viewer to see.

Three lights: Once you start using three or more lights, you need to be really careful about where you place them. It is very easy to accidentally place the lights in such a way that they conflict with each other. Highlights and shadows start to get all mixed up, and when that happens, you can end up with a very confusing picture.

Once you can use three lights adeptly to produce a well-lit scene with some subtle shadows, you're on your way to a whole studio setup. Next step: reflectors and diffusers! (See Chapter 7.)

There are many, many ways of using three or more lights. For example, you could set up a main light with a large diffuser to light up the side of your subject. Then you could set up a second light behind the subject aimed toward the camera but hitting the back of the subject, and finally add a third light with a colored filter on it to light up the background.

The key is to place your lights one at a time, looking for each light to do something very specific. It can be a mistake to simply set up a bunch of lights based on some formula that may or may not work for your subject. If you watch what each light does, one at a time, you will discover some great things that you can do with multiple lights. Do some test shots and check the results on your LCD.

NEW LIGHT SOURCES

In recent years, we have seen the introduction of some new lighting products that help photographers control light on the subject. Several manufacturers have created special fluorescent lighting fixtures designed specifically for photography. In addition, at least one manufacturer is creating a full line of LED lighting products.

These lights offer the continuous nature of a quartz light, but without the heat. They can be great alternatives to quartz or strobe lighting for a number of situations: Perhaps you're shooting portraits and the heat from quartz lights would cause the model to sweat, potentially smearing her makeup; or maybe you have a subject who always blinks when a flash goes off. One of these other types of lighting can also be a good solution for food photography where heat may be a problem. Color temperatures vary depending on the light, but that doesn't really matter; just set your camera's white balance properly and your colors should look natural.

This compact fluorescent light is a great alternative to quartz lights or studio flash. It's simple to use, it doesn't get too hot, and it even offers a built-in diffuser.

7 CHAPTER

Advanced Light Concepts

CHALLENGES AND SOLUTIONS IN LOW LIGHT

Low-light conditions are everywhere: in homes and offices, in an arena, in a high-school gym, at night on the street, at a concert, outdoors at twilight, in a restaurant, and so on. This light can be very interesting, but it frequently presents challenges for the photographer, including:

SHARPNESS

As discussed in Chapter 3, low light usually requires slower shutter speeds. This can make images less than sharp because of camera movement that occurs while you're hand-holding the camera, so use a tripod whenever possible. Subjects may also be blurred due to their own movement, in which case, you should set a higher ISO so you can use faster shutter speeds in order to freeze the action.

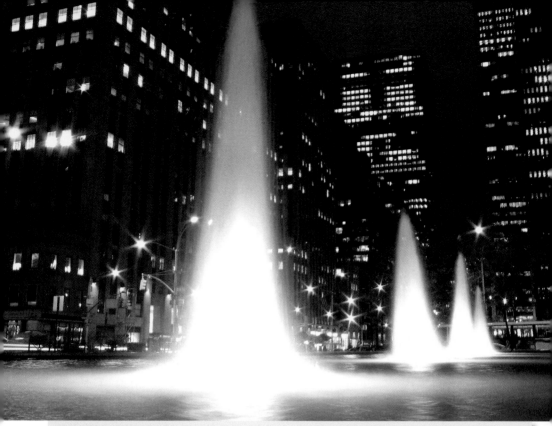

I set a low ISO number for this one so that there wouldn't be too much noise, and so that I could use a slow shutter speed in order to capture the motion of these fountains. Long exposure times cause noise, too, so I used my camera's long exposure noise reduction to keep it to a minimum.

In extremely low-light conditions, you may need to use a large aperture (i.e., f/2, f/2.8); while this isn't ideal because it drastically reduces depth of field, it can mean the difference between capturing an image and having a picture of an indistinguishable streak. There may be times, however, when that streak is what you're going for—subject movement can make for some very eye-catching photos.

NOISE

Noise is a challenge at low light levels because low light usually requires higher ISO settings, and high ISOs cause noise. Image noise is one area that Canon has been working on a lot, so noise is much less of a problem than it used to be. Canon D-SLRs exhibit

very low noise levels at all slow and moderate ISO speeds (up to 400 or so, depending on the camera) and fairly low noise levels at higher speeds. Still, there is always more noise from higher ISO settings compared to lower speeds. You can work around this issue to some extent by switching on (or turning up) your camera's high ISO noise reduction in the Custom Function settings. Be aware, however, that long exposures at high ISO settings will usually produce images with a lot of noise, no matter how much noise reduction you apply.

CONTRAST

Low light can be very contrasty. The reason for this is that there is little overall light (other than in business settings with fluorescents), and artificial light is often very localized. So, each light in a scene will appear bright, but areas outside of where the light falls can be relatively dark. To prevent harsh shadows and loss of detail in shadow areas, you can treat this light as you would bright sunlight; try to keep your subject within the highlight areas and/or use a reflector. (See page 178 for more on reflectors.)

LIGHT QUALITY

Low light levels bring a very different look to the scene and the quality of light than brighter lights do. This can add atmosphere to an image, or it can make a scene unattractive. As a photographer, you have to be aware of both possibilities and look for ways to work with the light that you have, rather than forcing a subject or scene into a composition that will not work with that particular light. This may mean moving the subject to a different part of a room for example, or a different location altogether. Perhaps if you are indoors and it seems the light simply is not going to work for the subject, it may be necessary to move outdoors.

LIGHT COLOR

Low light often also means varied colors to the light. It is common for low light to come from multiple sources, each a little different in color, meaning that even if you set white balance carefully, some parts of the scene will be neutral, some not. That can actually be an interesting element of existing light, but it can also be very distracting if you don't account for it in your images. Setting a Custom white balance may remedy this to some extent. (For more on the color of light and white balance, see Chapter 4.)

FOCAL LENGTH AND LOW LIGHT

In low-light conditions, your hand-holding technique is critical. The concept of focal length affecting sharpness in low light, along with a general rule for preventing camera shake, was discussed

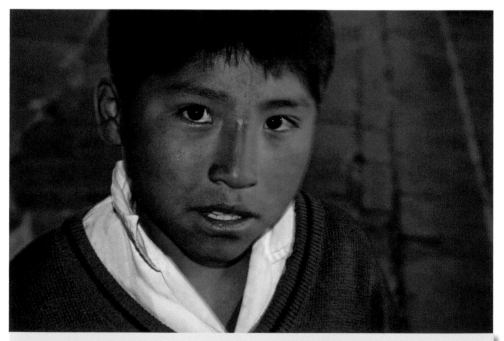

Hand-holding your camera to shoot in low light will often cause unsharpness due to camera shake, particularly with longer focal lengths. Long focal lengths can also magnify subject movement, so use them carefully when there isn't much available light.

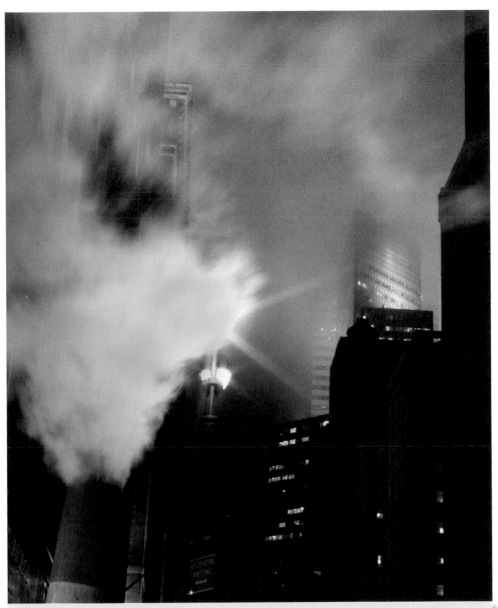

As discussed in Chapter 3, in the section about unsharpness with action, you may sometimes want to portray some subject movement in order to capture a sense of motion in a still photograph.

on pages 77-78. Here are a few of the principals behind that rule, which should help you adjust to specific situations:

◆ Telephoto lenses (and zooms) magnify the subject, but they also magnify camera movement.

◆ Telephoto lenses need faster shutter speeds than wide-angle lenses to gain equal sharpness of a scene. So, when you have to shoot at slow shutter speeds in low light without a tripod, try a wide-angle lens (or the wide-angle setting of a zoom lens).

◆ Wide-angle lenses can "handle" camera movement during exposure better because they see more of the scene, making movement of the camera during exposure less noticeable.

ISO SETTINGS

Chapter 2 explains ISO in detail, but here are a few ideas you can apply specifically to low-light situations:

◆ There is a misconception that only high ISO settings can be used for low-light conditions, but you can in fact use any ISO for any light. You can put a camera on a tripod or other support and shoot at very slow shutter speeds using a low ISO setting, and as long as your subject isn't moving, you can get some very sharp photos without the noise that comes along with using high ISOs.

◆ Use low ISO settings for highest quality. Low ISO settings limit your noise challenges and can give the best color, too, but in Canon D-SLRs, you will find only small differences between the low and moderate settings.

◆ Choose high ISO settings for fast motion. Light levels may drop, but that doesn't mean everything quits moving! High ISO settings mean you can use faster shutter speeds. If you shoot indoor sports, for example, you may need to really push your camera's ISO capabilities, going to the very highest settings, in order to be

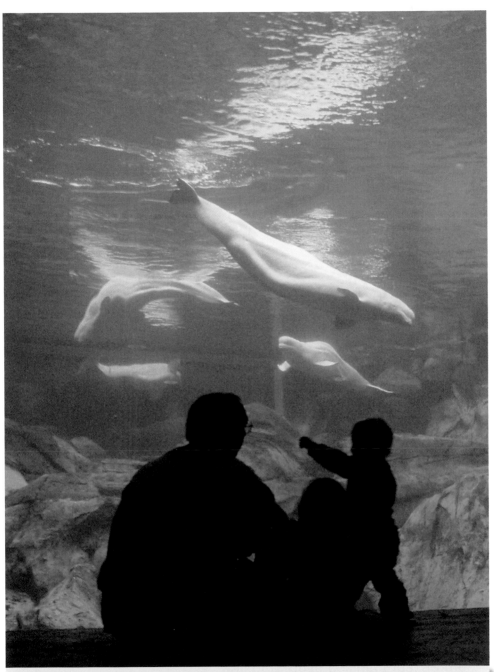

I simply had to make the noise sacrifice for this shot. Had I selected a lower ISO setting to reduce noise, any movement in the scene would have produced blur, which would not have suited this photo.

able to use action-stopping shutter speeds. In cases like those, a little noise (or even a lot) is better than blurry images.

◆ Select high ISO settings for hand-holding in low light. Faster shutter speeds also mean you can hand-hold a camera with the confidence that you are not getting blurs due to camera movement or "shake" during exposure. Again, a sharp photo with noise will be more pleasing than a soft image caused by motion blur.

◆ Use high ISO settings for moderate to low-light street photography. Street photography is when you walk in a city or town's active areas looking for interesting photos. You need to be able to quickly bring the camera to your eye and take a picture with reasonably small f/stops and moderate to fast shutter speeds, in order to capture quickly changing scenes. High ISOs will let you do that.

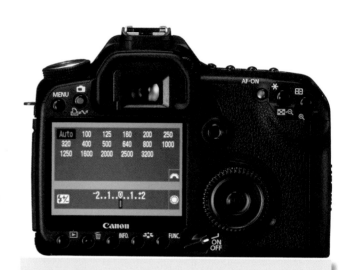

To set ISO on most Canon D-SLRs, press the ISO button and scroll through the choices, and simply resume shooting when the number you want is highlighted. Some models, however, require you to press a button to confirm your selection.

LIGHT DIRECTION AND ITS EFFECTS

Light can come from all directions around a subject: front, side, or back. When we look at how light affects a subject, we refer to a light direction in reference to the subject (i.e., front light hits the

Side light usually brings out more dimension and texture than front or backlight. The shadows on the right side of the subject in this example obscure her skin tone and hair color, while you can see those colors distinctly on the left, where the light is.

front of the subject as we see it from our camera position; backlight comes from behind the subject).

Light direction affects a number of elements in the scene. It affects the appearance of shadows, including where they fall. It affects the form, or three-dimensional look, of a subject and the scene. The combination of shadows and form creates texture (e.g., the roughness of the bark on a tree) which is then also affected by light direction. Furthermore, the colors and tonal patterns (contrast between light and dark areas) of a subject and scene are greatly changed when the direction of light changes. And finally, light direction can alter how pictorial elements in a composition separate from each other visually, including how

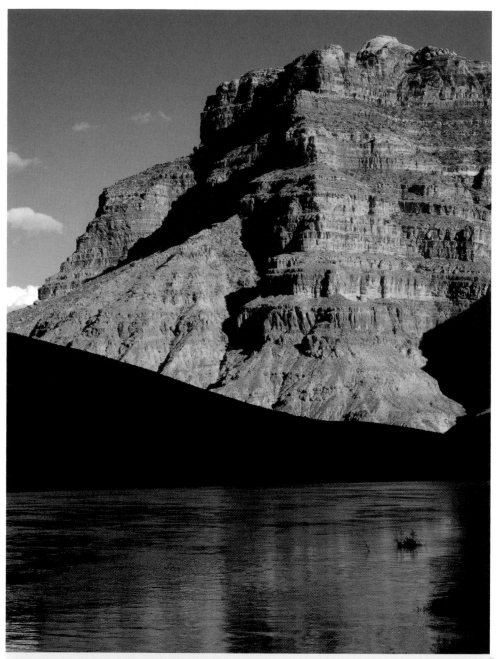

This side light is so strongly directional that the rocks cast distinct shadows. When shadows are this dramatic, they are really subjects on their own.

distinct from one another they appear, as well as depth in a photograph (the sense of distance between elements of the composition from the camera's perspective).

FRONT LIGHT

Front light comes from behind the photographer and hits the subject straight on. Since shadows fall behind the subject, they have little effect on the composition. Front light tends to be flat; the near-absence of shadows emphasizes two-dimensional shapes, deemphasizes three-dimensional ones, and removes the appearance of texture from a subject. Colors, however, are emphasized throughout the image, and will appear quite solid even if, in reality, they are more translucent. Differences in tone are very apparent because they are not obscured by shadow or texture. Separation of elements in the scene can be poor when the image is flattened out in appearance, as objects can blend with each other, and depth effects are also reduced.

SIDE LIGHT

Now light is coming from the side of the photographer and subject, illuminating one side and casting shadows around and to the other side of the subject; the shadows now have a much stronger effect on the composition. Because of the more apparent shadows, the subject's form will be well-defined. Texture will be at its highest, especially with a low, skimming side light, because shadows are so much a part of the image with that kind of light. Shadows and textures are likely to obscure color and color patterns, except in small areas of light. Separation can occur when a highlight on the subject is seen against a shadow behind it, but this is not always present in side-lit scenes. Depth can be strong or weak, depending on the amount and exact direction of the light, among other factors.

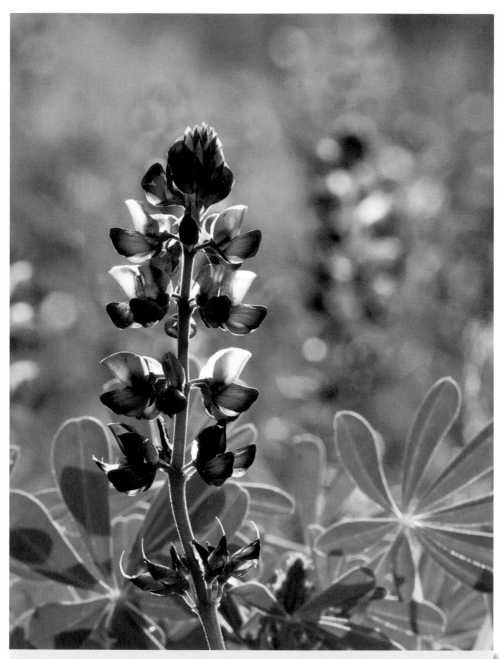

The backlight illuminates the translucent parts of this flower, making them glow and stand out—this is a prime example of what is referred to as "rim light".

BACKLIGHT

Backlight, as you may have guessed, comes from behind the subject. Since shadows fall in front of the subject, they can have a very strong effect on the composition. Form can appear two-dimensional if the subject is in silhouette, but it can be strongly three-dimensional if the light is high enough to provide light and shadow on the entire subject. Texture also can vary—from none, if the subject is in silhouette, to very apparent, if the light is skimming the subject from behind. Colors can vary quite a lot, too. Translucent colors glow and come alive, while solid colors and tones may be dull and obscured by shadow or bright highlights. Separation of pictorial elements can be very distinct when the light hits the edges of objects (rim light), or is high enough to create bright areas against shadows behind the object. Depth can be enhanced with this light—it can strongly separate objects, plus increase the feeling of atmosphere because backlight can light up the background.

REDUCING LIGHT CONTRAST

Contrast is a big challenge for all photographers. Digital cameras particularly have trouble dealing with high-contrast tonalities, and any scene that is already contrasty will appear even more so in a photograph. Here are five solutions to dealing with light contrast:

1. Turn your flash on: Every Canon camera includes the ability to turn the flash on or off, including forcing it on at all times. When set to P or Av mode, Canon cameras will balance that flash with the ambient light, filling in the shadows so that contrast is reduced, without overpowering the sunlight. You can check your LCD to be sure the balance is right. If it is not, Canon D-SLRs allow you to reduce the light from the flash by adjusting flash exposure compensation. On most Canon D-SLRs, you set flash exposure

You can use just about anything to block bright sunlight: cardboard, your hat, a companion, etc. For the photo above, I used a piece of black foam board to even out the light, almost completely eliminating the shadows. In the case of a big scene like the one below, you may just have to wait for some clouds if you want a softer light.

The sunshine in this scene was casting some very harsh shadows, so in order to make a more flattering photo, I used fill flash to light up those dark areas.

compensation for the built-in flash by pressing a button marked with ▣ and turning one of the camera's dials. Some of the newer accessory flash units have their own exposure compensation function, which you can set instead of setting it on the camera.

2. Wait for a cloud: This is a great solution if there are moving, sporadic clouds in the sky. Check the sky, noting the clouds and their movement, to see if you can wait for one to block the sun and create a more diffuse light.

3. Block the light: By blocking harsh light, you can get the equivalent of open shade on your subject at any time. You can use all sorts of things to block the sun ranging from your body (when shooting a macro subject), to a standing companion casting shade, to a large piece of cardboard or Fome-Cor® (white foam board. If the board is black, it will not reflect any light into the

shadows, which can create an even stronger effect). Blocking the light one way or another can be very effective for close-ups and portraits.

4. Use a reflector or diffuser: A reflector can be almost anything that is white or neutrally reflective—all you need is a way of bouncing sunlight into the shadows. People photos can often use the help of a reflector, though you may find a problem when the reflected light is so bright that it makes people squint or look away. The answer to that is to have your subject look down and away from the bright light until you are ready to take the picture.

Then you ask them to look into the camera, and you take the picture immediately before the bright reflector makes them squint.

You can, in effect, create your own "hazy cloud" between the subject and the sun by using a diffuser. Diffusers are neutral-colored, translucent, and spread the light out across their surface. (Read on to the next section for more on reflectors and diffusers.)

You can get creative with light modifiers. Try stepping into the shade, then reflecting sunlight onto your subject for a very subtle 3/4 light.

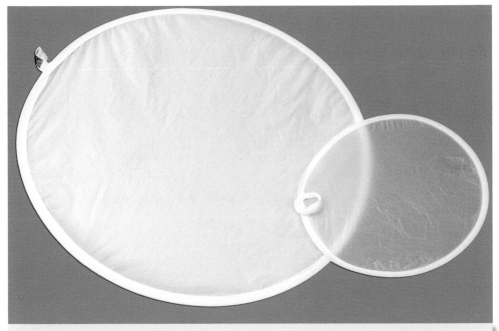

Reflectors and diffusers will help you better control the light coming from your flash, as well as light from other sources.

5. Look for another picture: When the light is really bad, you are better off finding a new setting than struggling with light that will never really help or flatter your subject. Harsh, high-contrast light that strikes a subject wrong can be obscuring, distracting, and sometimes downright ugly.

MODIFYING LIGHT

A modifier is anything that is placed between the light and the subject to change the quality or direction of the light. Studio photographers use all sorts of modifiers, but any photographer can use some simple ones to get better light. The important thing is for modifiers to be neutral in color and big enough to make a difference in the quality of the light.

How big a light modifier needs to be depends entirely on the size of the subject. A small, tabletop subject might be fine with something that is only a foot across, while a car might need a diffuser or reflector that is 20 feet (6.1 m) across to get the same effect.

REFLECTORS

One way of modifying light is to use a reflector; it works on the same principle as bouncing light does (as discussed on pages 150-152), but actually involves another piece of equipment—a reflector. A reflector is, of course, anything that reflects light, and it can be placed anywhere in the path of the light source for a nice directional, yet gentle light that avoids the typical harsh look of a direct source, especially flash. You can use a reflector to change the general direction of any light source. Reflecting light in this way also spreads it out, thereby helping to fill in shadows as well.

You can simply prop up a piece of Fome-Cor® near your subject, or you can buy folding reflectors that will fit into your camera bag. A white or silver photo umbrella is another option; umbrellas are just another type of folding reflector. Or, you can even go to an automotive store and buy a white or silver folding windshield screen. All of these things achieve basically the same effect: changing the direction of the light and/or filling in shadows. White reflectors do, however, give a slightly softer effect than silver ones.

You need to place a reflector in a position that will reflect the main light back onto the subject. You have to move it around to find the best position for the effect you want. Watch the shadows carefully and see how the position of the reflector changes them.

DIFFUSERS

Another way to modify light is to use a diffuser. A diffuser is anything that softens the light by spreading it out. Over the years, photographers have used everything from tracing paper to white,

Modifying your light, whether you bounce it or use a diffuser or reflector, will almost always make it nicer than direct light for portraits.

translucent shower curtains. If you are using quartz lights, remember that they are hot and can burn a diffuser. However, a diffuser should never be right up against the light anyway, or you will minimize its effects.

You can attach some tracing paper to a frame to try out a diffuser effect, but you will find that folding diffusers (including the so-called shoot-through umbrellas) make this much easier. You just have to have someone or something (small clamps and a light stand help) hold the diffuser between the flash and subject. The more spread out the diffused light source is, the gentler the light and shadows become.

CAUTION: *When using any modifier with a quartz light, remember that these lights are hot and can cause problems, including fire, if they are too close to any surface.*

8 CHAPTER

Lenses and Accessories

The lens is obviously crucial to photography because it focuses your subject onto the digital camera's light-sensitive sensor. You need the lens to limit the light coming from the scene to only what you need to capture an image.

Canon has a well-deserved reputation for making quality lenses. It can be surprising how good their lenses are on even small, inexpensive point-and-shoot cameras. And the top-of-the-line lenses for D-SLRs, the L-series, will rival any lenses on the market.

Modern computer design and manufacturing techniques, along with rigorous engineering work, have allowed Canon to build very good lenses quite economically. If you can't afford a pro lens, you can still get excellent images from low-priced optics. Where you will find differences between them and the higher-priced lenses, however, is in durability—Canon pro lenses are built to tougher standards, plus they are sealed against moisture and dust so they can keep working when pros abuse them in day-to-day shooting. Additionally, most pro lenses are faster (i.e., feature larger maximum apertures) than their less expensive counterparts.

THINGS TO KNOW ABOUT LENSES

As you learn about the use of lenses in the field, you will need to be aware of a number of features and drawbacks that can qualify how well a lens will work for your specific needs. Not all lens features are available in all lens types and focal lengths, nor are they needed for all photographers. But, you'll want to make sure you get the right lens for the job!

UNDERSTANDING FOCAL LENGTH

Focal length refers to the distance between a lens' optical center when it is focused at infinity and the focal plane (the sensor in the case of a digital camera), and it is measured in millimeters (mm). More millimeters of focal

Knowing what all the numbers and letters associated with lenses mean will help you understand the lenses you already own and make educated decisions when you purchase new ones.

length magnify the subject size; these longer focal length lenses are referred to as telephoto. Fewer millimeters make the subject smaller; and the lower numbers are considered wide-angle focal lengths.

A lot of photographers simply use different focal lengths as a way of framing a scene differently, i.e., seeing more of the scene with a wide-angle and less of the scene with a telephoto. Yet, your choice of focal length can affect a lot more than just subject magnification—it also affects perspective, depth of field, and much more. (See page 96 for more on how focal length affects depth of field.)

Perspective and focal length: Perspective in a photograph relates to how objects in a scene change in size as they are closer to or farther from the camera; it's about the relationship between size and distance. By changing focal length and your distance from a subject, you can change how perspective looks in a photograph.

The subject and the background appear to be farther apart here than they are in reality, because I used a wide angle to shoot the scene.

You can easily see how using a zoom lens can alter perspective using the following experiment. Find a subject that is a short distance in front of a distinctive background, and set your zoom to its widest setting. Get close enough to your subject that it fills most of the frame from top to bottom and take a picture. Next, zoom into the most telephoto setting of your lens. Then back up until your subject once again fills most of the frame—you are trying to keep your subject approximately the same size. Take another picture.

Although this is basically the same composition as the previous photo, everything appears to be closer together in this shot because I used a telephoto focal length to shoot it.

When you compare the two photos, you will immediately see a difference in the background. Even though you know the distance between the subject and background did not change, it will look like it did! The wide-angle shot will have a background that looks much farther away from the subject than it does in the telephoto shot. The wide-angle image therefore has a deeper perspective, while the telephoto has a flatter perspective.

You can use perspective control for creative effects or you can use it to simply make a livelier and more interesting photo. A sun setting over the mountains may look fine with a mid-range focal

length, but change to a strong telephoto and the mountain ridges become more dramatic against a larger sun. Or with a really wide-angle lens, you can get up close to a subject and make it totally dominate the image.

Angle of view: Angle of view refers to whether a lens is wide-angle, normal, or telephoto (see pages 192-201 for more on the various types of lenses), and is a function of both focal length and film or sensor size. A small sensor provides a smaller angle of view, i.e., more telephoto for a given focal length than a large sensor. A larger sensor means a larger angle of view, or a wider angle, for the same focal length. Focal length itself does not change—it is built into the optics of the lens—but a smaller sensor essentially crops your image frame, capturing a smaller scene and magnifying it.

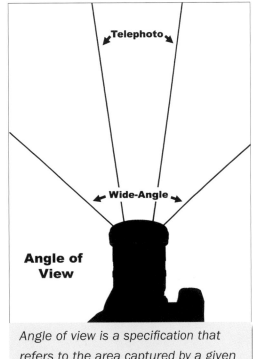

Angle of view is a specification that refers to the area captured by a given lens on a given camera.

So, Canon's small-format (APS-C) D-SLR cameras, compared to full frame cameras, magnify the subject in the image area by 1.6x. (*Full frame* is a bit of a misnomer. It actually refers to a sensor that measures 36 x 24mm—the same as a 35mm negative or slide—which is not a full frame in the world of film formats, as there are a number of formats that are larger than 35mm.)

This crop, or magnification, factor makes a 100mm lens act like a 160mm lens would on a full frame camera, i.e., more telephoto. As another example, if you have a 28mm lens, it would be a

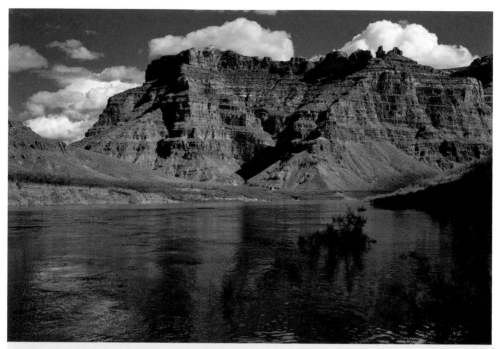

You can see here, in the differences between the two photos, that a wider angle of view (top) produces a more encompassing and far-away view, while a narrower angle of view (bottom) doesn't allow you to see as much of the scene and magnifies what you can see.

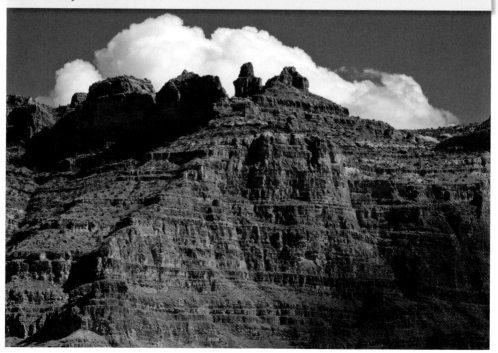

wide-angle on a 35mm film camera or on a digital camera with a 35mm sensor. But, since 28 x 1.6 is roughly 45, when you put that lens on a Canon small-format D-SLR, it will seem like a 45mm lens. 45mm isn't really wide-angle at all; that's considered a normal focal length.

LENS SPEED

Lens speed is important, but is often missed in discussions about lenses. The lens speed is related to the maximum aperture of a particular lens. You will see the lens speed listed with the focal length of the lens, such as 100mm f/2.8 or 70-200mm f/2.8. The f/number represents the largest aperture possible for the lens.

Large-maximum-aperture lenses like this one are expensive compared to their slower counterparts, but if you do a lot of low-light, action, or portrait photography, you should consider making the investment.

This is important because it also represents the maximum amount of light that can come through the lens. A lens that lets in more light is called a fast lens, such as 50mm f/1.8. A lens that lets in less light at its maximum aperture is called a slow lens, such as 17-85mm f/4-5.6*. The reason for the terms "fast" and "slow" is that a lens with a 1.8 maximum aperture will allow faster shutter speeds than an f/4 lens at an equivalent exposure.

* The fact that two numbers are given for the maximum f/stop, f/4-5.6, means that this is a variable aperture lens; the maximum aperture actually changes with focal length so that it is f/4 at 17mm and f/5.6 at 85mm. This points out an important aspect

of zoom lenses that you really have to pay attention to: the fact that you may have a slower lens at a longer focal length. Lenses are manufactured this way because it makes for a smaller and less expensive lens with the same optical quality. But you do lose speed as you zoom in. Higher-priced zooms, however, will often have one maximum f/stop for all focal lengths.

When you're shopping for a lens, read the aperture specifications carefully so you know if you're getting a fixed-maximum-aperture or a variable-maximum-aperture lens.

Lens speed affects the price of a lens by a great deal because to make a faster lens in the same focal length, Canon must use bigger pieces of glass and more lens corrections, and in general put a lot more engineering and cost into that lens. For example, Canon's 70-200mm f/4 zoom is considerably less expensive than the 70-200mm f/2.8 zoom, yet image quality is very similar. In addition, the latter lens is quite a bit bigger and heavier. The advantage, however, is speed: You can use a faster shutter speed or a lower ISO, plus more light comes through to the viewfinder for a brighter image when you're composing your shots.

DIFFRACTION

The concept of maximum and minimum f/stops can be confusing. Yet both have a significant effect on how a lens can be used. The maximum f/stop, as you've just read, is the widest aperture possible with a lens, for example, f/2.8 or f/4. The minimum f/stop

is the smallest aperture that can be set on a lens, for example f/16 or f/22.

It is true that as the aperture gets smaller, the depth of field gets deeper, thereby improving apparent sharpness, but only to a point. At the smallest apertures this opening in the lens becomes so much smaller that something called diffraction occurs, making a lens less sharp. Lenses actually tend to be at their best sharpness in the mid-range of f/stops, such as f/8 and f/11. Some lenses will be significantly less sharp at very small apertures; the only way to really know this is to test the lens.

FLARE

Flare is the result of light bouncing around inside a lens, and it can affect your photographs. It occurs when a bright light, such as the sun, is either close to your subject or is within the frame of the photograph (or just outside the frame). You're likely to see two types of flare effects: Diffuse flare, which softens the entire photo and has its strongest effect nearest bright light; and specular flare, which creates small light patterns across the image area in a diagonal pattern, coming from the direction of the light source.

A dramatic sun next to your subject can be striking, but you can get flare like this if you don't take precautions.

All lenses are susceptible to flare to some degree, but less expensive lenses tend to be more so, especially diffuse flare. You may find that with these lenses, the image loses a lot of contrast as you point the camera toward the light.

The way to prevent flare is to minimize the amount of light bouncing around inside the lens, which you can do by using a lens shade. You can also prevent flare by literally blocking the light from reaching the front of your lens. You can step behind something that casts a shadow over you and your camera, or you can hold something up in front of the lens to block the light. That can even be your hand. The trick is to look through your viewfinder and move whatever you're using to block the light until you see the flare disappear. Make sure, though, that it's not in the corner of your picture. A circular polarizer can also be a big help in reducing flare effects in your photos. (See pages 209-217 for more on polarizers and other filters.)

SPECIAL LENS ELEMENTS

All camera lenses are highly corrected to deal with aberrations that occur as they react differently to various light wavelengths, and therefore focus at different distances for different colors. Aberration can cause color fringing (false colors appearing along the edges of dark objects near the outer borders of the image) and softness (due to blurring of highlights), among other things. Flare can also be made worse by this effect.

There used to be a big gap in lens quality from the budget lenses to the most expensive models, but that is much less true today. Still, more expensive lenses will often have special lens elements to give even better lens correction. Canon uses something called low-dispersion glass in many of its top lenses, represented by an 'L' in the lens' model name. This is used in specific parts of a lens to help correct aberrations and produce cleaner color details.

Canon also uses aspherical lens elements in many of its wide-angle and zoom lenses. These are specially designed parts of a lens that change how light passes through it. They help correct for aberrations that come from wide-angle lens design.

You may also run into Canon's DO, or Diffractive Optics, lenses. These lenses also use special lens elements, but in this case, to make a lens smaller. These optics flatten a standard lens element to make it smaller without affecting its main optical properties. Some photographers like DO lenses a lot because they are smaller and lighter. However, they can produce a ring-like effect on out-of-focus highlights that some photographers do not like.

INTERNAL FOCUS (IF)

A relatively recent development in lens design is Internal Focus. Originally, all lenses focused by moving part of the lens closer or farther from the focal plane in the camera. The lens then got physically larger, which could really change its form and balance.

Internal focus uses optical mechanisms buried inside the lens to allow focusing to occur with no change in the outer dimensions of the lens. This means the camera/lens balance stays the same as the lens is focused. In addition, it allows the lens to focus without rotating the front element, making certain filters (such as polarizers) easier to use, an important feature, especially for landscape photography.

IMAGE STABILIZING LENSES (IS)

During the mid-1990's, Canon introduced to still photography an Image Stabilization (IS) lens that has an internal mechanism to shift lens elements in order to compensate for camera/lens movement during exposure. This allowed for sharper images at slower shutter speeds. This had been originally developed with

Sony for the film and video world, but Canon was the first manufacturer to bring this to standard photography.

IS has been a great benefit for photographers and Canon now has a whole series of IS lenses. Photographers are using IS to shoot hand-held at slower shutter speeds than they ever could before, and often with surprisingly good results. This is highly dependent on the individual and you will need to do some tests against results from a tripod to see how well you can do with IS.

IS is also useful with lightweight tripods and for people with physical ailments that prevent them from holding a camera still. Original versions of IS were never recommended with tripods, as they could actually introduce movement to a photo when the camera was on a tripod and using a slow shutter speed. With the latest versions, you can use IS lenses on tripods, and it can actually be a big help when you're using a lightweight tripod and/or when there is a lot of wind or vibration.

Some independent lens manufacturers now offer similar features that do the same thing. While these technologies help photographers hand-hold lenses at slower shutter speeds than normal, never use IS as a substitute for a tripod when conditions require extremely slow shutter speeds.

TYPES OF LENSES: FOCAL LENGTH

ZOOM LENSES

A zoom lens is one that can change focal length, or zoom in and out on a subject. Years ago, zoom lenses had some definite quality issues, but with today's lenses from Canon, that's really not an issue. Canon zoom lenses offer high quality in many focal lengths and varied price ranges.

The primary benefit of a zoom is that you get many focal lengths in a single lens. That can be a big deal. It means you can change

from wide-angle to telephoto, for example, without changing lenses; it also allows you to travel with fewer lenses; and it gives you the ability to precisely frame a subject even if you can't easily move toward or away from it.

PRIME LENSES

A prime, or single-focal-length, lens is the lens with which photography started. It has only one focal length, and cannot be zoomed to change focal length. The only way to change the focal length is to change to a different lens.

These single-focal-length lenses are almost always faster than zooms (i.e., larger maximum aperture)—even

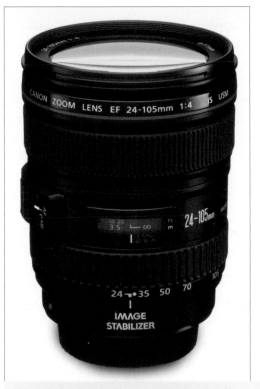

Zoom lenses are more convenient and usually less expensive than prime lenses. In the past, optical quality was not as good with zoom lenses, but today, some of them are every bit as good as prime lenses.

fast zooms—and can be a real benefit when shooting with telephoto lenses. They are also smaller than zooms of equal focal length and f/stop. Of course, a whole set of primes that matched a zoom range would be considerably larger and more expensive than one zoom lens, so there is a trade off.

Pros will pick primes when they need lens speed and when they can get by with only one or two focal lengths. They will choose zooms when they need to have the ability to constantly change focal length to match subject activity.

WIDE-ANGLE LENSES

Wide-angle lenses pick up an increasingly wide angle of view of a scene—the shorter the focal length, the more of the subject and its surroundings you see in the viewfinder and the final image. The result is that the subject size decreases. Wide-angle lenses are typically used for big scenes, such as landscapes, where you want to show a lot of the scene in a single image. They are also commonly used to achieve deep perspective effects. (See pages 183-185 for more on perspective.)

Wide-angle focal lengths for full frame sensors are 35mm and shorter; extreme wide-angles are 20mm and shorter, with a limit at 14mm (below 14mm is considered fisheye). Canon offers these focal lengths in both zoom and prime lenses, including some very fast prime lenses in this range.

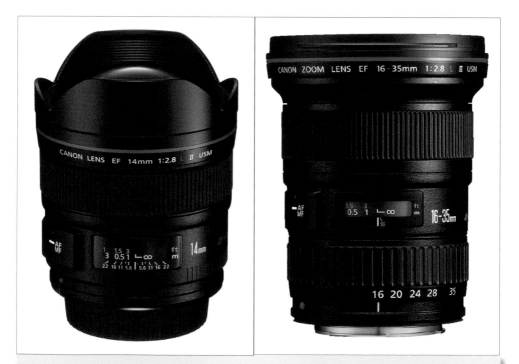

14-35mm is the range of focal lengths that are officially considered wide angle for full frame sensor cameras.

Wide-angle lenses are called so because they offer a wider angle of view than normal or telephoto lenses. They show a wide view of the scene and make its elements appear smaller and farther apart.

Wide-angle lenses for APS-C sensors are 22mm and shorter, with extreme wide-angle in the 14mm and wider range. Canon offers fewer choices in this range, though there are a few EF-S lenses that provide wide-angle capabilities specifically for smaller sensors.

FISHEYE AND FULL-FRAME FISHEYE LENSES

These lenses give a different look at the world compared to normal lenses. They capture an extremely wide angle of view, and thereby, straight lines become curved. A true fisheye lens will cover about 180° in front of the camera and show the scene as a circular image inside a black rectangle. That means you often get your feet in the picture if you aren't careful. At present, Canon

A full-frame fisheye lens shows an exaggerated, wide angle of view—so wide, in fact, that lines become distorted like the horizon in the photo above.

does not make this type of fisheye lens, although you may be able to find one in a third-party brand.

A full-frame fisheye is a unique lens for photographers. The name may seem a little confusing, because it sounds like it's for the 35mm ("full frame") format. However, what it actually means is that the lens will fill up the entire image area with what it sees. Lines will be curved and you will get an extremely wide-angle view, but the image will not be a circle. Canon does make a full-frame fisheye: the 15mm f/2.8 lens. It was originally designed for 35mm cameras, so you will not get the full effect of this lens when you're using a camera with an APS-C size sensor. Other manufacturers do make full-frame fisheyes for these cameras, however.

MID-RANGE AND NORMAL LENSES

Mid-range focal lengths capture the world in a moderate way— neither wide nor telephoto, and include the normal focal lengths. Normal varies from format to format, but in general, refers to lenses that "see" a perspective similar to how we see a scene with our eyes. For 35mm or full frame sensors, this would be considered to be approximately 45-55mm. For Canon's APS-C size digital format, this is about 30-38mm. These focal lengths have an almost invisible effect on the perspective of a scene and are considered to have a neutral way of capturing a subject.

Photos taken with normal-focal-length lenses look the most realistic because these lenses have almost no effect on perspective. You can look through the view-finder when a normal lens is mounted on your camera and see the scene with almost exactly the same perspective as if you simply looked at it with your eyes.

TELEPHOTO LENSES

Telephoto lenses see a smaller part of the scene—the longer the focal length, the smaller the area of the scene it captures, and the more that part of the scene is magnified (you will often hear telephotos referred to as long lenses). The name telephoto applies to a lens that is longer in focal length than a normal lens. Telephoto also refers to an optical design. Years ago, long lenses were all long indeed—as long as their focal lengths. Nowadays, however, telephoto design compresses the size of the lens so that it can be physically shorter than its focal length.

A short focal length for a telephoto is about 70-90mm for a full frame camera and 45-70mm for APS-C. This focal length gives only slight subject magnification and is often used for photographing people. A moderate telephoto is in the range of 100-200mm for full frame sensors and 65-130mm for APS-C. This focal length range is a popular all-purpose telephoto range, especially for many sports action photos and it works well for moderate perspective effects.

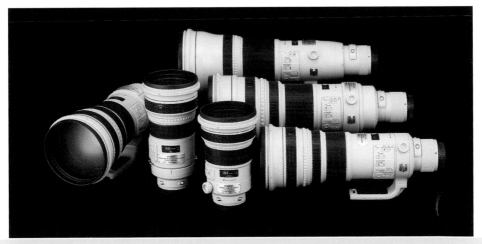

These high-end telephoto lenses from Canon are by no means the only ones they manufacture. Depending on your style of shooting and what you shoot, you may need to consider one of these, or you might get by just fine with a less expensive model.

Everything in these two scenes appears very close together because I shot both of these using very long telephoto focal lengths. To get a less compressed perspective, I would have had to move much closer and use a wider-angle focal length—a feat that could have proved impossible with the deer!

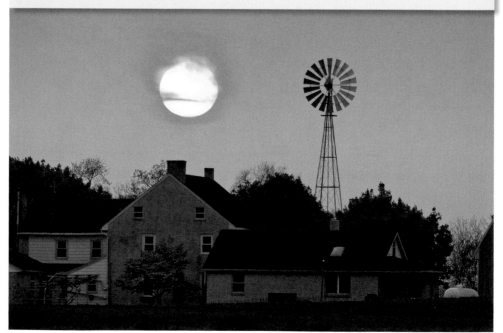

A long telephoto will be in the range of 300-400mm and 180-250mm for full frame and APS-C, respectively. These longer lenses are a necessity for wildlife and sports photography; they also show some strong perspective effects. Focal lengths above these are considered super telephotos. They provide extreme magnification of the subject.

USING DIFFERENT FOCAL LENGTHS

Here are some typical uses of focal lengths you might think about:

WIDE-ANGLE	MID-RANGE	TELEPHOTO
• Landscape photography	• Landscape photography	• Compressed landscape effects
• Travel scenes	• Travel scenes	• Wildlife photography
• Connecting subject with surroundings	• People photography	• Portraits
• Making scenes look deeper	• Making scenes look normal; avoiding dramatic effects (documentary-style photography)	• Isolating subject from surroundings and especially background
• Dealing with small interior spaces		• Flattening scenes
• Capturing large groups of things or people when space is limited	• Connecting subject with surroundings	• Making large spaces seem smaller
• Creating dramatic deep perspective effects		• Creating dramatic compressed space and perspective effects

NOTE: This chart is only meant for reference, and not to restrict uses of lenses to any of these subjects!

Close-up photography is a general term. It refers to any image that gives the viewer a close-up of the subject. The term has come to mean images taken "close-up" in distance, generally from approximately 2-3 feet and closer with normal focal lengths.

Macro photography is more specific. This refers to extreme close-ups that show off subject details not normally seen. You will see a variety of definitions regarding how close this is, but you can call anything that approaches a 1:1 ratio, or when the subject is magnified, a macro shot.

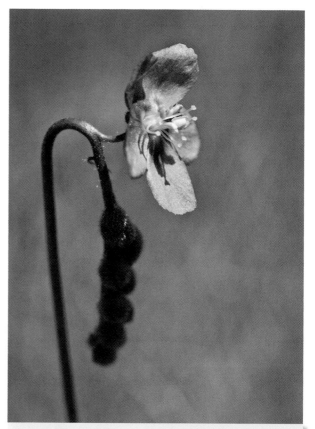

In the strictest definition, this is not a macro image because it isn't a 1:1 ratio. But, in recent years, the term "macro" has been expanded to include closely focused and magnified images, even if they're not quite captured at actual size.

The ratio 1:1 means that the subject has been captured at its actual size on the digital sensor. At that point, any use of that image will be magnifying the subject because you are obviously going to print or display it much bigger than the size of your sensor.

When it comes to SLR cameras, many people think macro lenses are the only way to do close-ups. While an effective close-up tool, a macro lens can be limiting if that is your only way to get close-

ups. I am going to give you a number of possibilities for close-up photography—they all work and can give you options to best fit your needs.

Most of Canon's zooms on the market focus pretty closely without added attachments. This makes close-up work quite convenient and can be a great way to get close-ups without having to carry extra gear. You will sometimes hear this described as macro focusing for a zoom. That is misleading—rarely do these zooms focus to truly macro distances, and if they do, they are not really optimized for sharp-

This Canon 28-135 lens isn't really a macro lens (i.e., producing its best sharpness at close focus-ing distances) but it will focus closer than most zoom lenses.

ness at these distances like true macro lenses are. If you do use one of these lenses, keep in mind that the close-focusing feature will usually be at its best when the lens is used in the middle range of f/stops (such as f/8 or f/11).

CLOSE-UP ACCESSORY LENSES

Sometimes called close-up filters, close-up accessory lenses screw into the filter threads at the front of your camera lens to allow closer focusing. They make close-up photography very easy, and can make a zoom focus close at all focal lengths.

Inexpensive single-element close-up lenses are typically sold in groups of three (not available from Canon). However, their

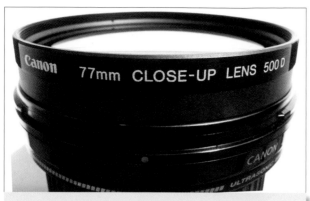

The Canon 250D and 500D are high-quality close-up lenses that offer a relatively inexpensive means of capturing close-up subjects.

image quality is not very good (this is why Canon doesn't make them) and will make photos look soft (which can also be an interesting effect).

Multi-element, highly corrected close-up lenses are a different story altogether. These lenses also attach to the front of your camera lens, but offer very high quality images. This is obviously dependent on the quality of the underlying lens, but results can match those of any other close-up gear. Canon makes two of these lenses: 250D and 500D. They only come in a few sizes, so you may need filter adapters, depending on what lens you're using.

EXTENSION TUBES

I think extension tubes are a necessity for anyone who wants to do close-up work with a D-SLR. These are simply optically empty tubes that fit between your lens and D-SLR camera body and make your lens focus closer (they also connect the two electronically as needed). As you shift a lens farther from the focal plane (where the film or sensor is), it will focus closer. There are no optics involved, so the cost of extension tubes is relatively low. Image quality is excellent, but is dependent on the quality of the original lens. Some lenses simply do better than others for close-up work, regardless of their quality at normal distances.

Extension tubes currently come in two models from Canon, the EF 12 II (a small 12mm version), plus the EF 25 II (a moderate 25mm version). (With EF-S lenses, you must use these current

models—older models will not fit properly and can damage your gear.) You can also purchase a group of three extension tubes from third-party manufacturers such as Kenko.

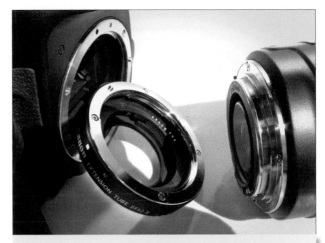

The EF 12 II and EF 25 II offer another fairly inexpensive way do close-up photography. The 25 allows for closer focusing than the 12, but also reduces the light reaching the sensor.

Extension tubes do not work equally on different focal lengths. When used with a wide-angle lens, a small tube can put you right on top of a subject, while the same tube may have hardly any effect on a telephoto lens. Also keep in mind that as a lens moves farther away from the camera, less light reaches the film or sensor. This requires an increase in exposure, which will be corrected with the camera meter, but will reduce your shutter speed if you keep the same f/stop.

MACRO LENSES

Macro lenses are specifically designed for optimum quality at close-focusing distances down to 1:1 or 1:2. Macro lenses offer the highest quality in close-up work, and one great feature is that they will allow continuous focusing from infinity down to 1:1 or 1:2 (since 1:1 means the subject is exactly the same size in real life as it is on the film or sensor, 1:2 is half size). Just like extension tubes, they lose light at the focal plane because they focus closer.

Canon offers a number of macro lenses, ranging in size from a moderate 50mm to a 180mm telephoto macro. There is also a

Macro lenses are the most convenient and consistently sharp, but the most expensive, way to do close-up shooting. Your needs and budget will determine what type of close-up gear is best for you.

specialty lens called the MP-E 65mm f/2.8 1-5x Macro Photo that is specially designed for extreme macro work starting at 1:1 and actually magnifies the subject up to 5x (a 5:1 ratio!).

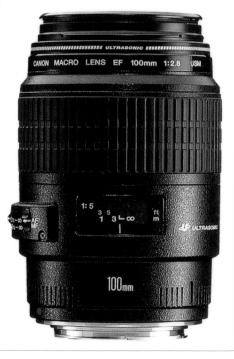

OTHER LENS ACCESSORIES

EXTENDERS

Canon's extender lenses (also called tele-extenders, teleconverter lenses, or extenders) fit in between your D-SLR and a prime or zoom lens. Similar to how a small sensor magnifies a scene, tele-extenders increase the effective focal length of any lens by the amount designated in the specifications, i.e., a 1.4x tele-extender makes an 85mm lens act like a 120mm lens. They are a relatively inexpensive way of increasing the magnification of a telephoto lens*, plus they are a lot smaller than carrying along another big lens.

Canon's latest extenders work extremely well, but they are only as good as the lens they are mated to. They can only magnify what the original lens is or is not capable of, and therefore, they will defi-

*IMPORTANT: TELE-EXTENDERS DON'T WORK WELL WITH WIDE-ANGLE LENSES AND OFTEN PHYSICALLY CANNOT BE ATTACHED TO ONE WITHOUT DAMAGING IT.

nitely magnify its flaws. They usually do not work that well with inexpensive zoom lenses, and often work their best with prime lenses. Most lenses work best with a tele-extender if stopped down to slightly smaller than the maximum aperture of the lens.

Finally, extenders reduce the light coming through the lens. A 1.4x extender, for example, will multiply the focal length by 1.4 but it will also reduce the light by one stop. A 2x extender will drop that light by two stops, which can limit your shutter speed and will often affect autofocus.

TILT-SHIFT LENSES

Tilt-shift is a special type of lens that affects how an image is placed on the sensor and can change the plane of sharpness in an image. Canon offers three tilt-shift lenses: 24mm, 45mm, and 90mm.

By shifting a lens, you can change what you see of the subject while keeping the back of the camera—and therefore the focusing plane—parallel to that subject. This allows you to keep straight lines straight; buildings, for example, normally look like they are leaning backwards when you tilt the camera upward because the edges of the building lean toward the center. A shifting lens will correct that.

By tilting the lens, you can also change the plane of sharpness within a photograph. Normally the plane of sharpness is parallel to the back of the camera. When you tilt the lens down, this plane of sharpness also tilts, so that you can get more things in focus from near the camera to far away without using a smaller aperture. You can also tilt the lens in other directions to create a very small area of sharpness within the picture.

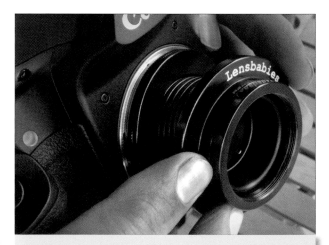

LENSBABIES

Lensbabies are unique lenses made by the Lensbabies company. These lenses act a little bit like tilt-shift lenses in the way that they move to change where focus is within a photograph. However, while they

Lensbabies lenses offer an inexpensive way to experiment with tilt/shift focus effects. They are really designed for unique soft focus effects due to tilting and shifting the plane of focus and can be a lot of fun to use.

do not have the high correction of a true tilt-shift lens, they are a lot less expensive and a lot of fun to use.

Lensbabies mount to a Canon D-SLR just like any other lens. The lens is housed in a flexible tube so that as you bend that tube, the plane of focus also shifts. You will get a sharp area in a photograph surrounded by increasing blur. You move that sharp area around within the image by bending the lens.

FILTERS

Filters comprise an important part of a digital photographer's tool kit: They allow you to control the image as you take it, which will mean less work on a digital photograph in the computer, or even no work at all if you are having it printed directly from the memory card.

A lot of filters have been rendered obsolete since the advent of digital, so, while you can get many different filters from your local camera store, mostly you won't need them except for special purposes. The following three kinds of filters, however, are extremely useful for digital photographers today: polarizing filters, neutral density filters, and graduated filters.

POLARIZING FILTERS

The polarizing filter, or simply polarizer, does some important things to colors in a photograph, plus it affects tonality, or brightness. A polarizer changes the way light hits the sensor—technically, it filters light waves so that only those with parallel form can get through. Rotating the filter then changes which of those can pass through. Therefore, you always have to rotate a polarizing filter to find the effect you want.

Polarizing filters will make blue skies darker, but the effect is variable depending on the angle to the sun (and rotation of the filter).

The maximum effect occurs at 90 degrees to the axis of the direction of the sun, which happens when your subject is lit from the side. The minimum (to no) effect happens when you are photographing directly toward or away from the sun. Since effectiveness varies according to the camera's angle to the sun, wide-angle lenses often capture an uneven sky—they offer such a wide angle of view that they can actually capture more than one area of coverage. Also, at high altitudes, skies may get too dark.

Polarizers also reduce reflections from non-metallic objects like glass or water. When you see unwanted reflections in windows and on water, you can

Polarizing filters, among other benefits they offer, can make a sky look bluer and make the clouds stand out more.

often keep them out of your images by using a polarizer. You may find, however, that the effect is too strong when the glass or water "disappears" making the photo look odd. In this situation, you can rotate the filter so you get the appropriate amount of reflection.

Since glare from shiny objects often obscures color, a polarizing filter can help you capture truer colors in your pictures. Direct glare of a bright light off of a shiny object, however, will not be affected. It is only the diffuse flare that comes from bright, diffuse light (such as the sky) that is affected. But, these filters can help you get some very dramatic effects—when photographing landscapes with shiny leaves that reflect the sky, for example. The greens will really pop when you reduce that glare with a polarizer.

Since haze is caused partly by light reflecting from water in the

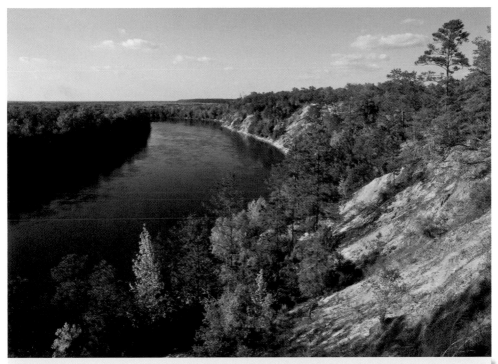

The sky looks richer in the photo below because I used a polarizer. You can make the effects of a polarizing filter less or more intense by turning it.

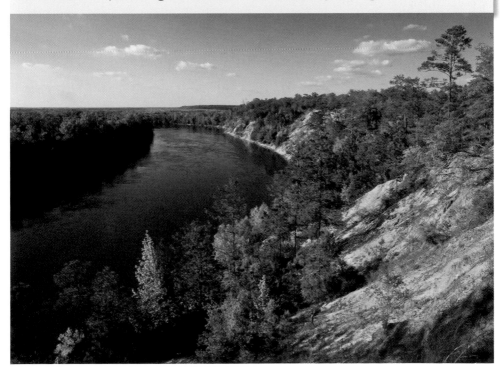

atmosphere, polarizing filters will also reduce the effect of light haze and give your pictures more contrast. (This reduction of environmental haze is part of the reason a polarizer makes skies look bluer, too.) However, they can't do miracles and remove haze altogether, nor do they have an effect on heavy haze or foggy conditions.

Although you may run across less expensive linear polarizers in old gear, be sure to use a circular polarizer with digital cameras. Most autofocus systems and many autoexposure systems have problems with the way light comes through a linear polarizer and can give irregular to downright wrong results.

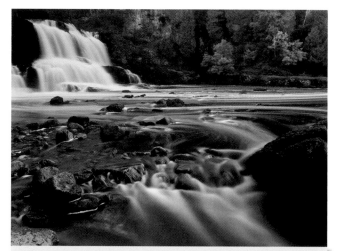

To use a polarizer, put the filter on the lens and rotate it until you see the effect you want. It is not a good idea to leave the polarizer on all the time—it significantly reduces exposure and makes the viewfinder much darker.

In order to use the slow shutter speed required to blur the waterfall, I used a neutral density filter to block some of the light in the scene.

NEUTRAL DENSITY FILTERS

Neutral density (ND) filters are dark filters that appear gray; they're actually black with different intensities. They reduce the overall light going into the lens for exposure effects. Mostly, they are used to limit the light enough that you can use slow shutter speeds in bright conditions. This can allow for creative blur effects on moving subjects, from runners to birds to cars.

It also allows for that smooth effect that comes from long exposures on moving water in situations where there would otherwise be too much light to use a long shutter speed without overexposing. A neutral density filter will also allow you to use a wide lens opening—for shallow depth of field, for example—when shooting in bright sun.

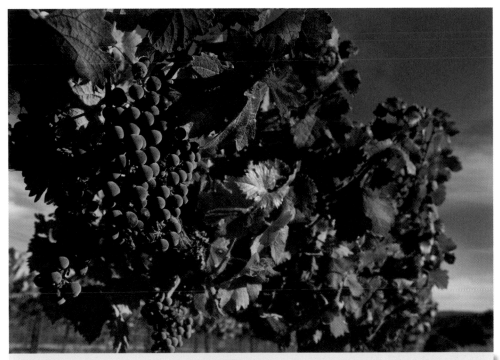

I used a graduated neutral density filter over the top right-hand corner of the scene so that I could expose the grapevine enough to show its details without overexposing the sky and rendering it colorless.

GRADUATED FILTERS

The graduated filter is half clear, the other half dark, in order to give a specific effect to part of the image area, while leaving the other part unaffected. It is usually graduated in tone across the middle, so that there is a smooth transition between the altered and unaltered parts of the image. When the dark half is a neutral tone, it is called a graduated neutral density (ND) filter, and may

also be referred to as a split ND filter, or simply a grad filter.

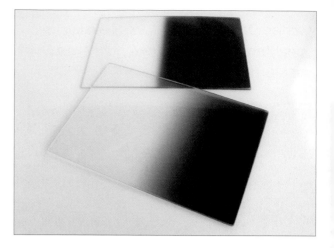

Landscape photographers commonly use graduated filters to help moderate extremes in tonalities between bright skies and dark ground. By rotating the filter (and/or sliding it in its holder if your particular filter is designed to allow that), the dark part of the filter can go in front of the sky, the clear part across the ground. The result is that the bright sky is reduced in tone, yet there is no effect on the ground. You can also get graduated filters in blue colors to enhance skies, or sunset colors to enrich sunrises and sunsets. Strong yellow grads are very popular with travel photographers because it helps them get a warm, romantic sky even if it doesn't exist in real life.

Graduated filters come with different blends across the middle. The most common is a soft edge that blends the dark and light parts of the filter quite nicely; these are very easy to use. Just put it over the lens, move it up and down (or rotate it, depending on the design) until the scene looks right, and take the picture. Check the exposure on the LCD if you aren't sure of your results. If it isn't quite right because of either the filter or the lighting conditions, make an exposure adjustment and try again.

Another common type of graduated filter is the hard edge. This has a sharp edge across the middle boundary between light and dark (instead of a gradual one) and can be used when there is a distinct edge between light and dark areas in the image.

All grads can be rotated so the dark and light can be used in different places on the scene. For example, you could put the dark down to reduce the brightness of a sandy beach in front of darker

water. Or you could rotate it over a bright window to knock that brightness down compared to the rest of the scene. The possibilities are endless.

Neutral density filters affect exposure, so keep in mind the focal length/shutter speed rule (page 78) and always carry a tripod.

PROTECTIVE SKYLIGHT/UV FILTER

These are basically clear filters that technically are made to filter out UV light, but they are commonly used to protect the front element of a lens. A lot of photographers use a "protective" filter over the front of their lenses. A cheap filter is easier to replace than an expensive lens, right?

Yet pros, who usually have very expensive lenses and cannot afford to have problems with them, almost never use protective filters. Expensive lenses are highly corrected, and an inexpensive filter can throw that correction off, making the lens less sharp. Every filter added to the front of a lens adds potentially reflective surfaces that can result in flare (filter-caused flare is a common-problem). Stacking filters by adding them onto one another on the camera can increase sharpness and flare problems, plus it can result in vignetting (darkening at the corners of the images).

A protective filter can give a false sense of security; photographers without a filter in front of the lens often take better care of those lenses. Pros will typically use a lens shade at all times on the lens, not just to keep out stray light, but also to keep fingers, twigs, and other things from even getting close to the front of the lens.

EXPOSURE WITH FILTERS

Filters do affect exposure. Most filters darken the scene, and while your meter will largely compensate, the result is slower shutter speeds, wider apertures, or both.

Grad filters may need exposure adjustments; sometimes you can use a grad over your lens and just use the meter reading. In other situations, you may need to reduce the exposure (underexpose from the camera's suggestion) to get the best results. Check your LCD and histogram to confirm what is needed.

Polarizing filters can give misleading exposure results: Consider shooting a composition with a large proportion of sky. In that case, the sky may become so dark that it fools the meter into "thinking" more exposure is needed, resulting in overexposed clouds and other bright parts of a scene. Be aware of this and look for problems in your LCD review and histogram.

My polarizing filter cut down the intensity of the bright sunlight in this scene, making it possible to capture the movement of the grass, plus it increased the saturation of the greens. It also made it necessary to use a tripod.

9 CHAPTER

Subject Tips

There are probably as many subjects as there are photographers. One of the great things about photography is that whatever your passion is, you can share it through pictures.

Of course not all subjects are easy to photograph. Many present unique challenges. Still, there are a lot of ideas that can be used to help you get better pictures with any subject. This chapter covers some ideas that might help you get better pictures with your Canon camera. The topics covered in this chapter are certainly not all-inclusive (whole books have been written on them), but they can certainly provide a starting place.

There's a reason why so many postcards feature photographs of city scenes: They make great subjects! A good photo of a city scene really captures the essence of the place and evokes a feeling of nostalgia for visitors and natives alike.

URBAN

CITIES AND TOWNS

Cities and towns can be fascinating subjects, and provide infinite photographic possibilities. It is important, however, to pay attention to the sky. A gray, cloudy day, for example, can be a terrible time to take pictures in the city because there's no definition to cloudy daylight. Usually, buildings need some definition to help them separate visually from each other and the surrounding landscape.

No matter what kind of light you're working with, though, look for planes, textures, color, and form—all elements that help define the parts of the city, as well as create interesting photographs. As discussed in Chapter Seven, light plays a big role in how texture, color, and form appear in your photos, not to mention shadows.

Also look for parts of a city or town that reveal details about the location. A telling detail is something that really grabs you and makes you say, "That is SO (fill in city name)." Look for those parts of the scene that really emphasize the particular qualities of the city or town. This can be a unique street, special architectural features, historic buildings, and so forth. Don't simply look for those "Kodak vistas" that everyone photographs. Find those parts of the location that mean something to you, that speak to you in a special way, and express something about the place.

Wide-angle lenses can be very useful when wandering a city or town, because they allow you to get in close to details that can create a dramatic foreground to the city behind them. It can also be interesting to look for details within the location by putting on a telephoto lens and surveying what you see. The obvious way to use a telephoto lens in urban photography is to capture interesting details of buildings and streets. Another way to use these

Use shadows! Dramatic shadows can really change a scene. There wasn't much happening on this small town street, but the shadows give clues as to what might lie outside the scene, intriguing the viewer nonetheless.

Light can be a critical part of architectural photos. The light here gives great form and texture to the building. Also, note the rich blue sky—I got that by using a polarizing filter.

focal lengths is to look for telephoto effects, like compression of distance, so that you can stack up parts of the city or town next to each other. (See pages 183-185 for a full explanation of focal length and perspective.)

ARCHITECTURE

A specific part of urban photography, architectural photography will provide you with endless subject matter no matter where you live. There are photographers who have made whole careers out of photographing architecture.

One thing that you have to be very careful of when photographing architecture is this: The building itself can be so dramatic that it seems like all you need to do is point the camera at it and you'll get a good picture, which is rarely the case. Light is going to contribute a whole lot more to a building's appearance in your photos than it does when you look at it with your eyes. While all photography is ultimately about light, architectural photography is *really* about light. The appearance of a building in a photograph is strongly affected by how the light affects its planes, textures, color, and form. Sometimes you can get a great photograph of a building simply by concentrating on any one of those elements.

When you point a camera up at a building, it may look like it is falling over. You can correct a moderate lean by using a tilt-shift lens, or in software such as Photoshop. You can also avoid it by keeping your camera vertical like the building (which may mean some compromises in your composition), by backing up if possible, and/or by shooting with more of a telephoto lens. Or, you can use this perspective effect artistically instead: If you are close and using a wide-angle lens, try getting really close to emphasize the extreme nature of the wide-angle lens as it affects perspective.

Just getting out there after dark and taking pictures of a city at night will get you some great photos, and the more you do it, the better the pictures will get!

CITIES AND ARCHITECTURE AT NIGHT

The digital camera has really changed the way we can approach low-light situations. Night photography in cities and towns has never been easier. Simply getting your camera out and photographing in these conditions will give you images that most other photographers don't have.

It is best to shoot at night with a tripod because light levels will be low and shutter speeds will be slow. You can get away with not using a tripod in cities, where that might be inconvenient, by using a beanpod. You can place a small beanpod between your camera and any solid object, such as a fence, a fire hydrant, or even a light pole. This will allow you to take pictures with very slow shutter speeds and minimize camera shake, but a tripod is always the most effective way.

I used Daylight WB to capture this warm glow. Also, on this night, I wasn't carrying a tripod, so I improvised: I set the camera to Av, opened up the aperture to its widest setting (which allowed a relatively fast shutter speed), and used a beanbag with the camera set on bridge railing to keep it as still as possible.

Wide-angle lenses work very well at night because they will not magnify the effects of camera shake the way a telephoto will. It can actually be difficult to use a telephoto focal length at night without a really solid support, because of the slow shutter speeds.

You will find that you can set your camera's white balance to a variety of settings and get good results. A daylight setting, for example, will produce a very warm look, while a tungsten setting will give a more neutral-looking light, which is appropriate for some scenes but may look too cold for others.

It can be a lot of fun to include a road with traffic on it when photographing a city night scene. Use an ISO and f/stop to give you a shutter speed of several seconds. The headlights and taillights of the moving cars and trucks will create streaks of color across the exposure. These patterns will continually change as you take pictures, so keep trying with different flows of traffic.

NATURE/SCENIC

LANDSCAPES

Composition is always a key element of landscape photography, which is no problem, since that landscape is not going to move. Light may change and require you to set up a camera quickly, but you always have time to consider how the image should be composed. Look through your viewfinder as if you are looking at photographs—as you move the camera around to view various portions of the scene, you can decide what looks good within the frame of the viewfinder and turn that into a photo.

One way to really work the composition of a landscape is to look for foreground / background relationships. This will add detail to a scene that will draw the viewer's eye into it and toward the background, making for a rich visual experience. Use that foreground consciously. What is in it, and how can you move to include something interesting in that part of the composition? The

worst thing to do is to simply frame up on the big landscape and hope for the best for the space above and below it. Work that frame by finding interesting shapes, colors, and objects in the foreground to include in the composition.

This foreground idea can also give you the opportunity to say something special about what you find unique about the scene. I'll explain with an example: Suppose you are photographing the Grand Canyon from a famous overlook. Everyone who has visited that scene has the same background. But then you start looking for something in the foreground that catches your eye: a special rock, a tree, flowers, whatever. Now, when you include that foreground, you know that not everyone has this photograph. And what you choose for that foreground can reflect what you feel about the scene, e.g., a tree barely holding on to the rocks says something very different than a big, solid rock dominating the foreground.

Although it isn't a dominant part of the image, the stream in the foreground gives more context to the photo and serves to lead the viewer's eye back into the bigger scene.

The rocks in the foreground and the early sunlight on them in this land/water-scape really make the photo. Cover them up with your hand, and you can see how uninteresting the picture would be without them.

CLOUDS AND SKY

Sky is a key part of most big scenes, from nature to cities, and can make or break your photo. A common challenge with skies is a washed-out, blank appearance. If the sky is full of featureless clouds or there aren't any clouds, keep it mostly out of the pho-to—show just a small section of it in the frame to define the top edge of the scene and to add some depth to the photo.

Filters will always help reduce the problems associated with pho-tographing the sky. A polarizing filter will deepen sky color, make a

gray sky appear bluer, or bring out flat-looking clouds. Remember, it works best when you are shooting at a 90° angle to the sun.

A graduated neutral density filter will darken part of the sky and make it more striking. A colored grad filter will add some color to make it more interesting. (See pages 209-215 for more on graduated and polarizing filters.)

The sky at sunrise and sunset can be very dramatic, especially if you use a wide-angle lens to capture more of the nuances in color, away from the sun itself. Contrast can be very high at that time, so look for interesting silhouettes in the foreground, as more detail will be difficult to expose for properly. Also, keep photographing past sunset, because the sky often has some incredibly rich colors at twilight.

The appearance of clouds in the sky changes significantly with the direction of the light. Backlit clouds may cause exposure headaches, but they are always dramatic. Be wary of too much overexposure, however, because clouds do need tonal detail to

Clouds can accent a scene; or, if they're striking enough, they can even be the subject of your photo!

Try to show at least a little bit of sky in outdoor scenes like this one. It provides context and perspective—an unchanging element that the viewer can use as reference—like the sharp unmoving object in the action shots I talked about in Chapter 3.

make them look right. Side-lit clouds can be an important part of a landscape. Front-lit clouds generally only occur when the sun is close to the horizon and behind you, and they often exhibit vibrant colors. So, when you're shooting at sunrise or sunset, don't forget to look around. While the sun itself may be quite beautiful, there could be another awesome scene right behind you.

FLOWERS

Flowers bloom nearly everywhere; get close and you'll find extraordinary displays of color, form, and design. Isolating a flower in a photograph can really help you capture its unique beauty and show off its display of design and color. There are three key ways of isolating your subject from the rest of the photograph, and they are all related to contrast. Contrasting a flower against its background will immediately create a visual dominance for the flower and allow you to clearly define your composition.

The first isolation technique is tonal contrast: The flower can be lighter or darker than the background in order for it to stand out.

By moving around, you can almost always find a contrasting tone behind your subject. Sometimes the contrasting background area is too small. A way to deal with this is to use a telephoto lens. If you back up to keep the flower the same size as it was with a wider-angle lens, the telephoto will magnify the background.

The second isolation technique comes from the use of color. Anytime you can put a distinctly different color behind your subject, the subject will stand out. By moving your camera position slightly, you can often find multiple colors to use. The most obvious color contrast is one that uses completely different hues. For example, a red flower will dramatically stand out against a solid band of green foliage behind it, or an orange flower will be bold against a blue sky.

The third isolation technique is sharpness. Any time you can make your subject sharp and the background unsharp, your

All three separation methods are at work here, but the most prevalent is the color technique. This pink flower stands out nicely against the green foliage in the background.

Here, I primarily used the sharpness method. The flower is tack sharp, while the background is completely obscured in unsharpness.

subject will stand out. This can be a very effective technique when your flower subject is the same tone or color as whatever is behind it. To use sharpness as a contrast tool, the subject must be sharp while things behind it are out of focus. The quick and easy way to deal with this is to use the widest apertures on your lens. Choose something like f/2.8, f/4, or f/5.6 (the smaller numbers like 2.8 offer more sharpness contrast, but not all lenses have them). This will give you a very high shutter speed (in really bright light, you may need to use a neutral density filter to cut the light, or use a smaller f/stop). Be sure to focus carefully on your subject, because if the sharpness is even slightly off, the image will not look right.

Telephoto focal lengths can help in isolating your flower through sharpness contrast; they will reduce depth of field, even if you can't use a very wide aperture. Another thing you can do is move around to find an angle to your subject that offers more distance between it and the background. If you get down to the level of the flower, the background is often much farther away, and therefore, less in focus.

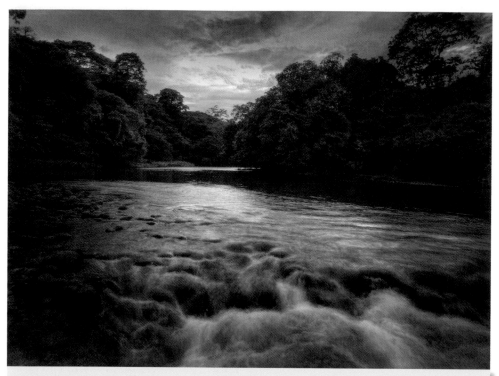

A combination of still and moving water can make for an interesting dynamic. The still water in the background reflects light and colors from the trees and sky, while the moving water in the foreground takes on a milky look due to a moderately slow shutter speed.

WATER

Water is such a terrific subject for photography. It looks great when it's moving, it looks great when it's still. Water can be part of a larger scene, it can reflect its surroundings, or it can be a wonderful subject all on its own.

There are two ways of really getting movement to show up with water: use a fast shutter speed to freeze its action or use a very slow shutter speed to blur its action. In-between shutter speeds, where the water is not really sharp but not really blurred either, generally don't give the best look to water. Exactly what shutter speed is needed depends on the speed of the water.

With rapidly moving water, you may need a shutter speed of 1/500 second or faster. You want to freeze the water into little droplets and rivulets, which can make for very dramatic images.

Moving water generally looks best in a photograph when it is made to look like it's moving. To achieve this, you're going to need to start with shutter speeds around 1/2 second or slower. Slower shutter speeds will blend the movement so that you are literally capturing the flow of the water—the slower the shutter speed, the more obvious the blur. Shutter speeds of several seconds can give a very interesting milky look to the water. You may need to use a neutral density filter to drop the light coming into your camera so that you can use a slow shutter speed without overexposing your images.

One of the appeals of still water is its ability to reflect surroundings. Look for something interesting to reflect into that surface. You may have to move around, or move higher or lower with your camera to find that interesting reflection. You may also need to use a graduated neutral density filter to darken a brighter part of the picture so that you can expose for the darker reflection.

A polarizing filter can intensify water by removing reflections. You might want to do that when the reflection is of a blank sky. However, you do need to be careful that you don't remove so much reflection that the water literally disappears.

THE ANIMAL KINGDOM

WILDLIFE

Wild animals don't generally let you walk right up to them. So, you'll probably need a telephoto lens if you want to do much wildlife photography. You need to magnify the animal so that it occupies a bigger portion of your image frame.

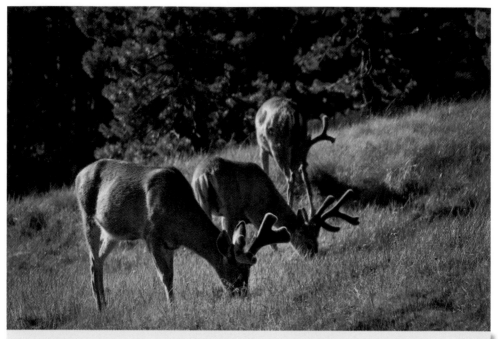

Most wild animals are either afraid of humans or dangerous, so the longer telephoto lens you use, the more likely you are to get good photos of them.

Normal focal length for 35mm is 50mm (see page 197-198); six times that focal length would be 300mm, about what a six-power pair of binoculars offers. Eight and ten times would be 400mm and 500mm, respectively. These are reasonable focal lengths for photographing wildlife.

Here are some rough guidelines to help you decide what focal length you will need for your Canon camera for specific types of wildlife photography. The first number is a lens size for full frame, 35mm-size sensors; the second is the appropriate focal length for the smaller APS-C size sensors (1.6x magnification factor). (See pages 185-187 for an explanation of the APS-C magnification factor.)

◆ **200mm/125mm:** This is really the minimum focal length for practical wildlife picture taking. It will work with larger animals in situations where they are used to people (and not viscous or

dangerous) and can be used in a photo blind (a structure you can hide in or behind so animals aren't scared away by your presence) in some situations.

◆ **300-400mm/185-250mm:** good all-around focal lengths for wildlife. This size lens is large enough to magnify a wary animal onto your film or sensor, yet there are models available that won't require a loan against your house or a new truck to transport them.

◆ **500-800mm/300-500mm:** These are focal lengths that the pros use for some of the most elusive animals. These are mostly large and pricey lenses, but if this type of photography is important to you, you may have to consider them.

I used a 600mm equivalent focal length to get this shot. Remember that you have to use either a very fast shutter speed or a tripod, although I recommend the former because if you use too slow a shutter speed, you'll have subject movement (not just camera shake) to worry about.

DOMESTIC ANIMALS

Domestic animals—our pets, livestock, and so forth, can make great photographic subjects. In general, the big difference photographically between wild animals and domestic animals, is that you can actually get close to domestic animals pretty easily. But, because we are so used to domestic animals, it is also easy to take them for granted when we are photographing them. That can sometimes result in mere snapshots, as opposed to artful photographs. You can liven up your animal photos in a number of ways:

◆ **Look for gestures.** Animals will have moments where they exhibit silly, cute, or otherwise unique behavior. Be prepared for that by setting your camera so that you can shoot immediately. Autofocus plus a fast shutter speed can help a lot.

◆ **Photograph a moving animal.** Animals in action, fully engaged in activity can make for great images. You need to shoot a lot of pictures, however, because this action will be continually changing, so it might be hard to catch. Use a fast shutter speed, AI Servo autofocus, and your fastest continuous shooting drives.

◆ **Use a telephoto focal length.** By backing up a bit, and using a telephoto focal length plus a wide f/stop, you can get some good separation of the animal from its background.

◆ **Get close and use a wide angle.** This is actually a trendy and popular technique for photographing dogs in recent years. When you get in close, you change the perspective on the animal itself, usually making the head appear much bigger than the body. This can be a dramatic effect, and the dog probably won't mind you getting that close.

If you want to get some good shots of your pets, keep your camera in a place where you can quickly reach it when they do something cute like this.

INSECTS

Insects can be amazing subjects. Butterflies bring us stunning colors and shapes, dragonflies are like flying jewels, ladybugs are a joy to discover, cicadas stun us with their life cycles, caterpillars offer wonderful, slow-moving subjects, and the list goes on.

Like all animals, insects need food and shelter. Any place that has lots of different kinds of plants will have lots of insects. Flowers are a good place to look for insects. There will be insects feeding on the leaves, others feeding on pollen and nectar in the flowers, and there will be predatory insects there to eat the rest.

Bugs don't always let you get close, so having a telephoto with extension tubes or a macro telephoto lens can be a great help. You also have to be careful as you move in to photograph an insect. They generally have an excellent ability to discern a moving

The sharpness contrast technique discussed in the section of this chapter about flowers works great for a variety of close-up subjects, including insects (and is even sometimes inevitable because of the loss of depth of field associated with close-up photography).

shape against the sky, and they are usually spooked by it, plus, no animal of any kind associates rapid movement with safety. Furthermore, insects and their kin are generally very attuned to vibrations. They can sense heavy footfalls on bouncy soil, and they will often bolt the instant they feel any movement in their plant. So, be sure to move slowly and deliberately.

Since most insects are basically the same temperature as the air, they tend to be more active in warm weather. Active bugs on a warm summer day can be very frustrating to photograph. Early morning is a great time to photograph bugs and such critters because lower temperatures and dew on them and their surroundings will slow them down.

PEOPLE

PORTRAITS

People photography has long been a part of the tradition of photography. The portrait, a formal way of taking a picture of a person, has been common since photography began. While there are many things to consider when creating a portrait, four things stand out that are really basic to getting a good image:

◆ First, focal length has a strong effect on the look of a person. A moderate telephoto can give a good perspective on a person's face when you're getting a tight portrait of that subject, although strong telephoto lenses can flatten a person's face and make them look heavier. A wide-angle lens tends to make faces look silly when shot up close, but a wide-angle lens is good for an environmental portrait showing a person in a certain setting.

◆ Second, the light on a subject's face is critical. A softer light, i.e., a light that comes from a larger source, such as a diffused or reflected light, is gentler on the features and details of a face. If that light comes from directly in front of the person, it tends to be a bit flat, so it often helps to move the light a little bit to the side

of the camera. If the light comes from the side and is too strong, you can get a very dramatic picture, but it can also be hard to keep it flattering.

◆ Third, the background has a big effect on the portrait. A lot of detail or bright colors in that background can be distracting from your subject. It often helps to shoot your subject with a limited depth of field and with the background some distance behind the subject, so that the background stays out of focus.

◆ Fourth, the eyes must be sharp. Eyes are absolutely critical to any portrait. You must watch to be sure the focus of your camera is on those eyes and not on a different part of the face. The portrait will never look its best if the focus is on the nose or the ears, for example.

Use moderate telephoto focal lengths and either diffused or bounced light for the most flattering portraits.

CANDID PHOTOGRAPHS

Getting photographs of people in natural settings and doing regular things is what candid photography is all about. A big part of this is taking the picture of the person so that they do not look awkward or uncomfortable. The timing of your shot is really important. Look for gestures and interesting postures. The right gesture can make a great picture of any person.

You'll have the most success if you do not come at your subject as the "PHOTOGRAPHER!" What often happens is that photographers will pick up a camera and brandish it a little bit too obviously, becoming *that* photographer, and gaining too much attention. You need to know your equipment very well, so that you can leave it at your side and subtly bring it up to your face when you need to take a picture, quickly take that picture, then put the camera back down by your side.

Set your camera on autofocus and autoexposure. This is one situation where Program autoexposure can be beneficial, and

Candid shots can still be candid when your subjects know they're being photo-graphed, as long as you're not so intrusive with the camera that they aren't able to act natural.

Auto white balance can really help too. You want to be able to take pictures quickly and easily.

It helps to shoot with just a camera and a zoom lens. If you have a bag full of gear that you're constantly rummaging around in, you will find it harder to capture pictures of people naturally going about their business. A telephoto focal length can be useful, because it can allow you to capture images of people without being right next to them. However, a wide-angle lens can give you some unique perspectives.

You can still get candid photographs of people who know that you are taking the picture. The key to this is also being very comfortable with your camera. Don't make a big deal about taking the pictures, just keep your camera handy and take a picture when something interesting happens.

Try using your camera's continuous drive mode to increase your odds of getting good sports action shots.

SPORTS

Sports is often synonymous with action. There are certainly some great sports photographs that come from candid images of emotional athletes not in action, but it is the stopped action that usually catches our attention. You can buy the Canon D-SLR with the fastest shutter speeds and the most advanced autofocus, then study all of the tips given earlier in this book about using fast shutter speeds with action, but the number one way of getting great action shots, as I mentioned before, is to know the subject! I can pretty much guarantee that anyone who really knows the sport is going to get consistently great action photos.

One of the best training grounds for dealing with action is a high school track meet. These are lengthy affairs with constant and varied action: There is the deliberate and graceful movement of

Daytime sporting events are a great place to get started with your sports photography, especially if you don't own any fast lenses. The daylight will provide you with more than enough light to use the fast shutter speeds you need to freeze action.

a discus thrower, the intensity of a sprint, the rhythm of hurdlers, the changing pattern of a triple jumper, and so on. Even if you know nothing about an event, there are always warm-ups and continuing events that repeat action so if you miss it once, you can get it the next time.

A key element of any sports action photography is timing. Without timing, you get movement of a subject, but not a high-action photo filled with impact. Sure, many fast action shots rely on a bit of luck—you can't always see the action as it happens. You have to react quickly and be sure you press that shutter button!

This is especially true for sports with peaks of action, such as the high point of a pole-vaulter's arc or the tag of a base runner at second. With many cameras, the speed of the continuous shooting option is not fast enough to get the shot at the best moment. That best moment often occurs in between shots. If you know the action and can time your shooting for it, even with a slower-shooting camera, your images will more likely hit the timing needed for impact.

EXPERIMENTAL

LIGHT PAINTING

Light painting is an interesting way of capturing a very unique image of your subject. With light painting, you shoot in a dark situation and point a bright light at your subject. Then you constantly move it over the subject while the shutter is open. You are literally painting with light.

The key to this is to have a dark enough situation that you can use an exposure of 30 seconds or more. Longer exposures give you more opportunity to paint your light over the subject. Your exposure should be set to make this scene look dark, as the main

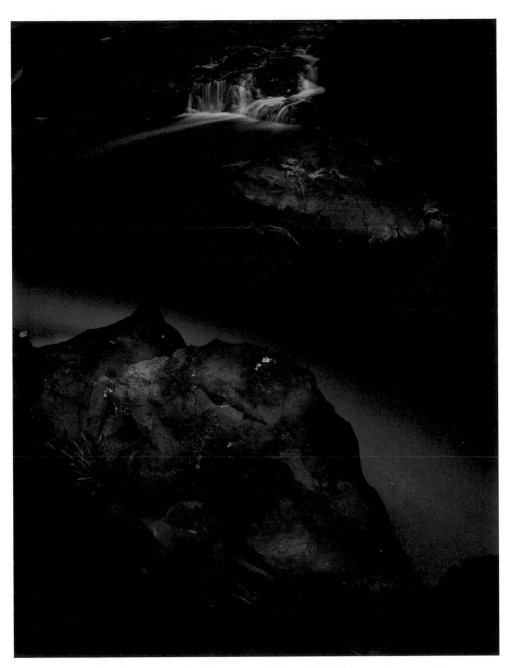

light is going to be coming from your flashlight, or whatever you use as a "paintbrush."

Put your camera on a tripod, and either set a long exposure or use a cable release with the B (Bulb) setting. Bulb will leave your shutter open as long as you keep the cable release pressed.

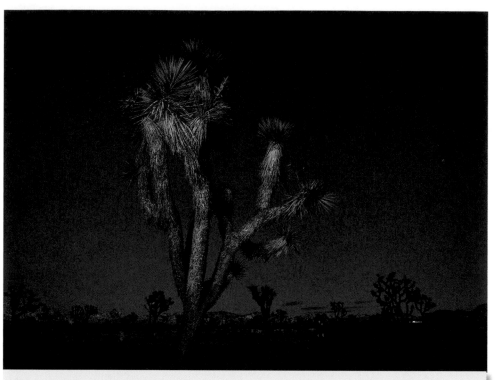

To paint light onto a subject like this, you'll need a fairly powerful light source. Try an industrial-type flashlight.

Canon even makes a cable release with a timer so that you can set your exposure to whatever you'd like.

You'll need a bright, focused light. The light needs to be focused in some way so that it does not go all over as you paint. Small LED lights work for close subjects, while big spotlights work well for distant subjects. How bright a light you need depends on how far away the subject is from your light. If you are painting a small, nearby sculpture, you can use a very small light. If you are painting rocks in a landscape, you're going to need a much bigger light. Set the white balance on the camera based on this light. You may have to take a test picture to see what the color of this light actually is.

Open your shutter and turn on the light. Start moving that light continuously across your subject. Move it more in dark areas, less

in bright areas; keep your light a shorter time on close parts of your scene, and longer on the more distant parts. If you're using the Bulb setting, close the shutter when you're done. That's all there is to it. You may have to experiment a little to get the results you want, but that's what the LCD on your camera is for!

FLASH BLUR

Flash blur, or slow sync, as discussed in Chapter Three is a great way to get an interesting and dramatic photo that is blurred and sharp at the same time, by using flash together with a slow

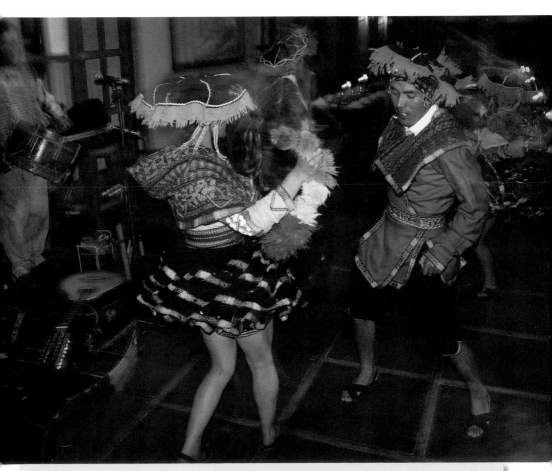

You can use flash blur, or slow sync, to capture your subject's movement, but still capture a sharp image of most of the elements in the scene.

shutter speed. Part of the subject or scene is sharp while the rest is blurred, and both sharp and blur can even occur with the subject itself. This has been an impactful technique for a number of years and many photographers use it.

Its effects are totally unpredictable. The shutter speed is really key, because it affects what the movement blurs look like. Too fast a shutter speed will just make those blurs look slightly fuzzy, as if the unsharpness were an accident. Too slow shutter speed and all the blurs will start to fight with the sharp part of the picture. Your best bet is to start shooting and keep shooting. You may get a lot of junk, but you'll also get some images with real impact. (See pages 89-90 for more on this technique.)

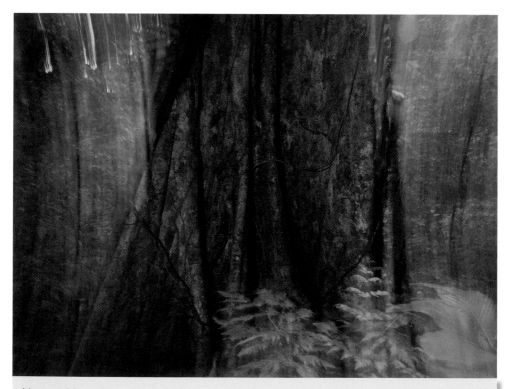

Your subject doesn't have to be moving for you to use slow sync—you can just move the camera instead!

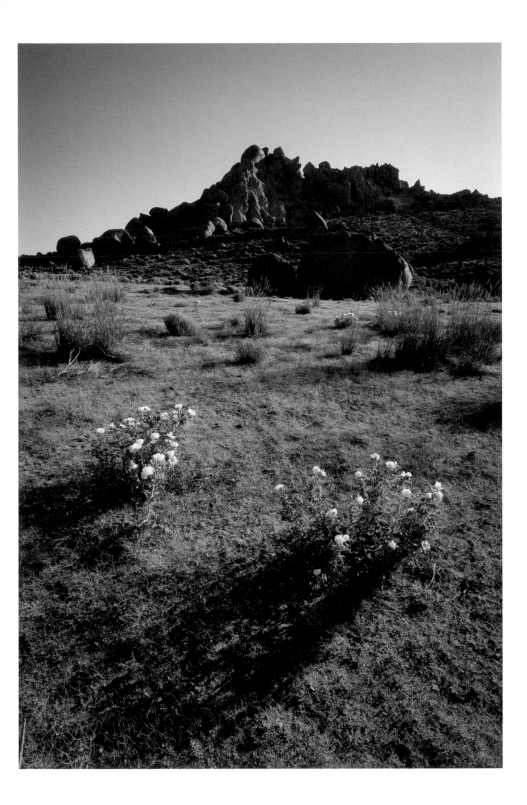

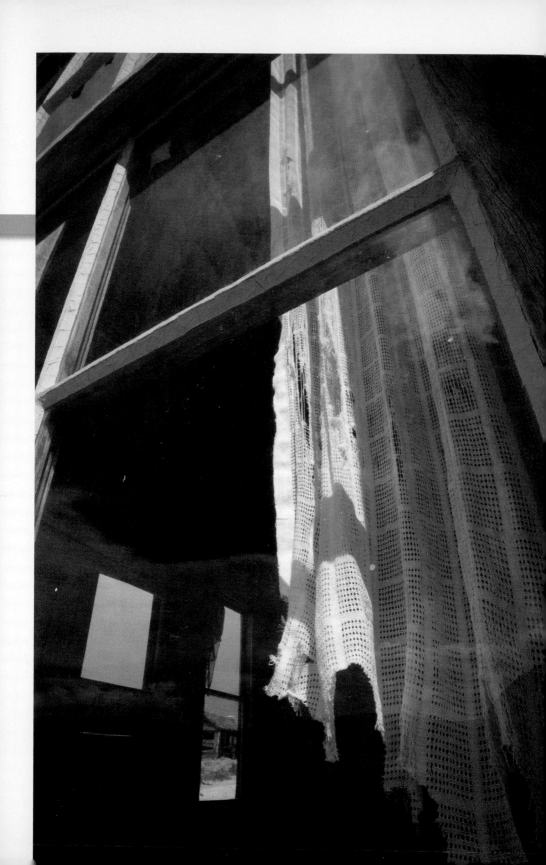

Camera Maintenance and Protection

A ny camera is a precision instrument. If you take care of it, it should work well for you for a long time. I have seen photographers abuse their gear and take it for granted, then get mad when it doesn't work right. A little care goes a long way in making sure that your camera works the way it's supposed to.

The different classes of Canon cameras are built differently. More expensive cameras are built to withstand more demanding use by professionals such as photojournalists. Photojournalists are often forced to abuse their equipment. They have no choice but to photograph when conditions are bad, whether that is rain, dust, smoke, or worse. For that reason, the most expensive Canon D-SLRs are built to a very rugged standard.

All Canon D-SLRs are well built, but the pro models are made to withstand a lot of abuse. That durability costs plenty of money, but to many photographers, knowing their camera is unlikely to stop working at an inopportune time is worth the investment.

They have many seals throughout the camera to keep dust and water out of the body—although it is important to realize they are water and dust *resistant*, not water- or dust-proof. Additionally, many of the parts of these cameras, such as the shutter, are built for high-intensity use.

This does not mean that the less expensive cameras are built poorly. In fact, many of these cameras have features similar to the pro models. But a less expensive model, such as a digital Rebel, is designed to be an economical entry into digital photography for the average photographer, but will not hold up under the extreme conditions that a photojournalist might challenge it with.

All cameras will last longer and work better if protected from damage by extreme conditions and if they are kept clean. Cleaning your camera body, lens, and sensor are important regular maintenance needs of any camera.

KEEPING YOUR CAMERA CLEAN

DEALING WITH DUST

Dust is a problem for digital cameras. Once it gets on a sensor, it creates unwanted spots across the scene, which can be very noticeable in light areas such as sky. D-SLRs, because they use interchangeable lenses, have more problems with dust than compact cameras. Every time you take a lens off a camera and put on a new one, you increase the possibilities of dust getting onto the sensor (technically, the dust is not physically on the sensor, but on a protective piece of glass in front of the sensor).

Just behind the mirror inside your Canon D-SLR is some very sensitive circuitry. Keep a lens or body cap on your camera at all times to keep dust from finding its way onto and into those parts.

You can check to see if you have dust on a sensor with this simple test: Point your camera at blank sky and take a photograph of it with one stop overexposure. Now, look at that shot carefully—enlarge it, move it around in the LCD. Do you see any soft-edged, black dots? Those are dust spots.

A number of Canon cameras now have built-in dust removal capabilities. Typically, this means that a cover in front of the sensor is designed to repel dust and it will vibrate rapidly when the camera is turned on or off so that dust will be shaken from the sensor. These cameras do show a distinct drop-off in dust problems.

What if you don't have one of these cameras? The suggestions set out below will help you to prevent dust from getting into your camera. Frankly, even if you do have a camera with dust removal capabilities, you'll have still better luck keeping dust at bay if you follow this advice:

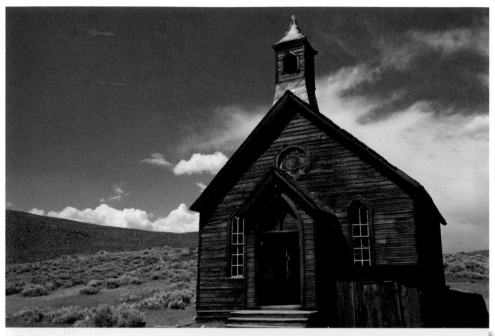

The red arrows point to spots in the image caused by dust on the sensor. If you see this in your photos, it's probably time to clean the sensor.

◆ Be careful about how you change your lenses. You do not have to turn off your camera to change a lens. This may sound contradictory to advice that you have read before. However, when you remove a lens from a Canon camera body, power is automatically shut off to the sensor. This removes any possibility of a static charge that might attract dust. Keep the time a lens is off the camera to an absolute minimum. Have the new lens ready before you take the other one off, so the new lens can go on the camera immediately. Be very careful about changing lenses in dusty or windy conditions (you may be better off putting on a zoom lens and leaving it on).

◆ Watch where you put your rear lens cap. A lot of dust actually comes from pocket lint because people put rear lens caps into their pockets. Another large portion of dust comes from putting lenses into a bag without a rear lens cap on, and from just dropping rear lens caps into a bag. Dust that gets on the lenses' rear

elements and mounts will then get inside the camera body when the lens is put on the camera.

◆ Keep your camera and lenses clean. Use a blower or a soft brush to regularly clean off the outside of your camera and lenses. Use a slightly damp (not wet) cotton cloth to clean the outer surfaces (not lens glass, though) if you have been in dusty conditions.

◆ Clean your camera bag. If conditions are dusty or dirty, or if you have been using a bag steadily over a period of time, get out the vacuum cleaner and thoroughly clean it out. If a bag gets very beat up and dirty, throw it out and get a new one.

CLEANING YOUR LENSES

Sooner or later, all lenses will start to get dust, smudges, and other funk on them. Dust can increase flare, softening the image contrast inappropriately, and can be seen as little, white, out-of-focus dots when using a wide-angle lens shooting toward the sun. And, any foreign matter on your lens can reduce its sharpness.

Cleaning a lens is easy and important, but you do have to be careful that you do not scratch the lens surface. Always blow or brush off the surface of a lens first before wiping it with any kind of cloth, because dust or dirt on the lens element can scratch the glass when it's pressed against it. Canon does, however, add some very tough coatings to the surfaces of their lenses that help protect them and make them easier to clean.

For dust, use a strong blower, such as Giottos Rocket Blower. Use it to blow off the dust from the front of your lens. Sometimes this is all you need to do. Another thing that can be used to clean off a lens is a clean camel-hair brush. You can get this type of brush from an art supply store or a camera store. It must be kept clean, and never brush the bristles of it against your skin, where it will pick up oil.

If there is still some dust or grunge on your lens, use a special microfiber cloth made for lens cleaning. You can get these from a local camera store. These are very soft cloths that clean a lens without damaging it. You do need to keep these cloths clean, so that they do not get debris in them. Breath softly on your lens to put a little bit of moisture on it, then wipe the cloth gently over the lens surface. It helps to keep the cloth folded, so that you can apply pressure to the fabric without it pressing too strongly against the lens.

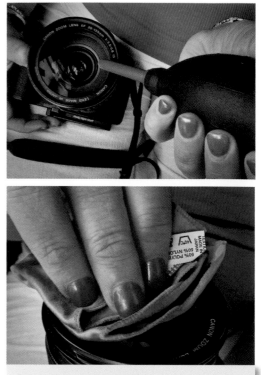

Clean your lenses gently and only with recommended materials to keep the glass in tip-top shape.

If you *still* have gunk on your lens, then you will need to use some lens cleaning fluid. Use special fluid that is designed for camera lenses. Never drip the liquid directly on the lens, as it can get inside and cause damage to internal parts. Drip the liquid onto the microfiber cloth or onto a lens cleaning tissue, then wipe gently. In a pinch, you can use a clean piece of cotton cloth to clean a lens. Cotton is soft enough that it shouldn't hurt your lens.

CLEANING THE SENSOR

Cleaning a sensor is important, but it is also something you have to be very careful of. You want to be sure you do not damage anything on or around your sensor. Do not use compressed air, do not apply liquids directly to a sensor, and never put a sharp object anywhere near the sensor.

To clean your camera's sensor, follow the directions in the camera's manual very carefully. Sensor cleaning is pretty consistent among Canon cameras now, but still, check your manual to be sure there are not special instructions for your model. When you clean the sensor, your shutter and mirror will be open. They need to remain open while you are cleaning, so be sure you have a fully charged battery before starting the process. If you lose power, the shutter and mirror may close on your cleaning tools, causing damage to the inside of your camera.

Be sure you are in a windless area, such as indoors or in a car. Take the lens off the camera, then point the camera so the lens opening faces down—that way, as you blow dust out of the mirror box, it will fall out of the camera. Use a strong bulb-type blower, such as the Giottos Rocket Blower, and start by blowing out the area around the lens mount and the mirror, but without touching the mirror itself.

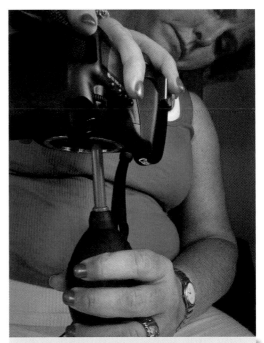

Next, turn the camera to its sensor-cleaning mode by going to the Setup menu. This menu will give you specific instructions as to how to continue. When the mirror and shutter are open, still keeping the camera pointed down, blow out the inside of the camera with the bulb blower. When you are done, turn the camera off and the mirror and shutter will close. Put the lens back on.

Blow the dust off of the mirror before cleaning the sensor, and hold the camera as shown so the dust falls out of the camera instead of just moving around inside.

There are quite a few sensor cleaning products on the market; some of them do work,

but they are rarely needed unless you have something really stuck to the sensor, but dust doesn't usually stick. Sometimes photographers will use a wet cleaning tool before they really need to, which just shoves the dust to the edges of the sensor. Then when the liquid dries, the dust is free to reapply itself to the sensor. So, perform a conventional, dry cleaning of the sensor before you consider those other methods.

Important things to remember about sensor cleaning:

◆ Be sure you don't touch anything inside the camera with the tip of the blower.

◆ Never use compressed air, as propellants can damage a sensor.

◆ Make sure you either install a fully charged battery or connect to an AC power supply before you begin cleaning the sensor.

YOUR CAMERA AND THE ELEMENTS

Canon cameras are made to handle all sorts of conditions, but a little care on your part will help them come through for you whenever you need them. Pro cameras such as the 1D and 1Ds series are designed with special seals to keep out dust and water, but still, these protections can break down if you are not careful. If you

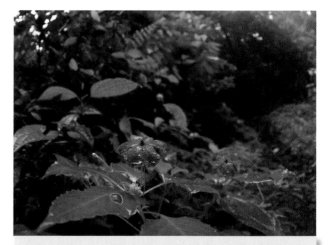

Rainy days can be a great time to capture some beautiful, deep colors, but you must take measures to protect your camera.

need to shoot under tough conditions, there are some things you can do to ensure that your cameras and lenses will keep functioning properly for you.

RAIN

Water and cameras do not mix. Rainy days can offer opportunities for some interesting photography, but they can also threaten your camera. Pros who have to shoot frequently in the rain will use Canon's pro cameras, which have sealed joints to keep rain out. L-series lenses are also sealed to help keep water out.

You can protect any camera, however, with some simple accessories. When I am in rainy conditions, I will typically keep a small, portable umbrella in my camera bag. This can be an immense help when you are shooting with a tripod and can hold the

The necessity to cover your camera doesn't apply only to rainy days. Be careful of extreme humidity and misty conditions like these, too.

umbrella over the camera. OpTech USA makes an inexpensive plastic cover called the Rainsleeve that can be easily kept in your camera bag and will cover your lens and camera, and is more appropriate for when you must hand-hold the camera. When you stop at a hotel, you can keep the shower caps, and use them to cover your camera, and they pack compactly in your camera bag. You can also buy very sturdy rain covers that are designed for a specific camera and lens combinations, such as those from Kata.

Finally, remember to dry out your camera bag and camera whenever you can. I will use a hairdryer set on low to dry a camera, on high to dry a camera bag (but don't get it too close to plastics).

SNOW AND COLD WEATHER

Cold weather conditions will not damage your camera. Modern Canon cameras and lenses are designed to function well in a wide range of temperatures including well below zero. Digital cameras actually work better in the cold compared to old film cameras, because you are not moving something through the camera as you shoot. Film used to pick up static electricity charges and would often break in subzero temperatures.

The biggest challenges for cold weather shooting are batteries and condensation. As batteries get cold, they lose power. When you're shooting under very cold conditions, it is a good idea to keep extra batteries in a warm place such as a pocket next to your body. Then, when the camera starts to lose power, swap those batteries. When the cold battery warms up, it will work fine. Some photographers will actually strap a warming packet against their battery compartment when the weather gets very cold. These little packets are generally available from outdoor stores.

A cold camera and lens will immediately pick up condensation when it is taken into a warm location. This can be a real problem, because it can result in water on inside parts. Whenever you are

moving from a cold location to a warm location, put your camera into a camera bag that can be tightly closed. Or, you can put your whole camera bag into a garbage bag and close it. Then, bring this inside to warm up slowly, and you will not have problems with condensation.

Condensation can also come from your breath. Never breathe on a lens or your viewfinder's eyepiece in cold conditions. This will cause condensation that may turn to ice, which will be a problem to remove. Never rub ice off of a lens, as it can scratch the lens; melt the ice first.

You won't get condensation by moving a warm camera into cold weather. A warm camera can be a problem with snow, however. The snow will melt on the camera and then act like rain. In snowy conditions, it is usually best

What a beautiful scene! Don't let the cold and snow keep you inside, but do take precautions to avoid condensation when you bring your camera back in from shooting on a day like this.

to let the camera get cold before you take it out and use it, so that the snow is easily blown or brushed off.

Condensation can be a threat to cameras in the summer months, too, thanks to air conditioning. But, if you're in the desert or any other arid place, you probably have nothing to worry about.

HEAT

Heat is a big problem for digital cameras. Electronics of any kind can be adversely affected by heat. Extreme heat can increase noise levels in a digital camera's images. In addition, lubricants within a camera and lens can lose viscosity and be displaced by the heat, and get into places they don't belong.

The best thing is to keep your camera as cool as possible. Simply getting a foam ice chest or cooler can help. You don't even need to put any ice in it. Simply put the camera and lenses into the cooler when conditions are hot, such as in a parked car. Be very careful of leaving camera gear in a parked car in hot conditions.

Be careful, also, if you bring a camera into an air-conditioned space. That can cool a camera down enough that when you bring it outside, you will get condensation. This is not a big problem in desert areas, but it can be where there's humidity.

THEFT PRECAUTIONS

Canon cameras are, unfortunately, well-recognized as a popular camera brand, which makes them targets for theft. No one is immune from camera theft, but there are some things that you can do to minimize the threat:

◆ Use a non-descript camera bag that doesn't say "Canon" right on it, advertising what's inside.

◆ Use a locking system, like Loc-Safe to protect your gear while you're eating or waiting for transportation.

◆ If you must leave your equipment in a vehicle, make sure you park the vehicle where you can see it and/or put camera gear into a diaper bag, cooler, or other inconspicuous container.

◆ Always be careful of how you carry your equipment. If you're carrying a camera across your chest, keep a hand on it at all times; and if you feel that you're in a dangerous area, it may be best to just put your camera away.

I have been around the world and have yet to have a camera or lens stolen. I certainly know it is possible, and I have known folks who have lost gear due to theft. I hope I never face the problem of stolen gear while traveling, but to lessen the odds, I do all of the things mentioned here. I can't guarantee nothing will happen to your gear if you do the same, but I can tell you that if you do nothing as a precaution, sooner or later, you will have a camera stolen.

INDEX